CUSTOMER SERVICE EXCELLENCE **Libraries & Archives**

Kent
County
Council

D0413546

Author: Gabriel Séailles
Traduction: Barbara J. Barling

Page 4:
Head of the Virgin in Three-Quarter View Facing Right,
1508–1512
Charcoal, black and red chalk, 20.3 x 15.6 cm
The Metropolitan Museum of Art, New York

Layout:
Baseline Co., Ltd
127-129 A Nguyen Hue
Fiditourist 3rd Floor
District 1, Ho Chi Minh City,
Vietnam

Published in 2006 by Grange Books an imprint of Grange Books
Plc The Grange Kingsnorth Industrial Estate Hoo, nr Rochester,
Kent ME3 9ND www.grangebooks.co.uk All rights reserved

ISBN 10: 1-84013-923-4
ISBN 13: 978-1-84013-923-5

Printed in China

Forword

"Details make perfection but perfection is not a detail."

— Leonardo da Vinci

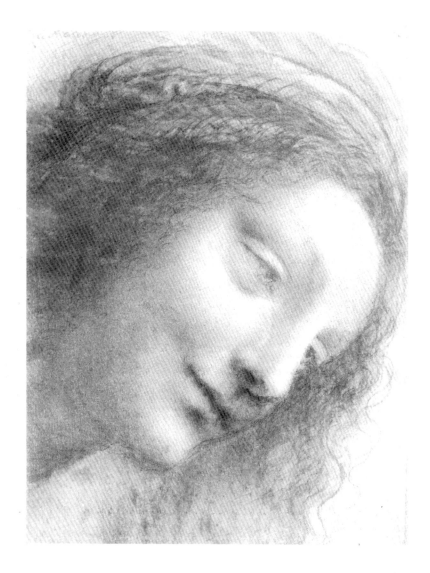

Biography

1452: Leonardo is born on April 15th in a small Tuscan town called Anchiano near Vinci in the Florentine region. He is the illegitimate son of a wealthy notary, Ser Piero, and a peasant girl, Caterina. His father takes charge of him after his birth, while Caterina leaves to marry another man. His two parents, each of them remarrying, give him seventeen brothers and sisters.

1457: Leonardo goes to live with his father, who had married Alberia Amadori.

1460: The young man follows his father to Florence.

1469: At the age of 15 he becomes an apprentice in the famous studio of Andrea del Verrochio in Florence. There, he is responsible for part of the altarpieces and for some large painted panels as well as for sculptures in bronze and marble. He draws an angel in one of the Verrochio's paintings which so impresses his master that the latter vows never to paint again. Leonardo remains in that studio until 1477.

1472: He enters the painters' guild.

1473: Leonardo paints the first of his famous works, La Valle dell'Arno.

1478: He receives an order for an altar panel for the Vecchio Palace, a project which is never completed.

1492: Leonardo leaves Florence for Milan. He manages to enter the service of Ludovico Sforza, Duke of Milan, after boasting in a letter to him of his talent for building bridges, ships, cannons, catapults and other war machines. In fact, it is because he professes to be a musician beyond compare that he is given the post he requested. He remains as an artist in the court of Milan for eighteen years, paints numerous portraits and creates the decorations for palace parties. His fascination with complex mechanisms becomes more intense, and he studies at length physics, biology and mathematics, applying his new knowledge to his duties as an engineer. However, Leonardo's interests are so broad that he often leaves projects unfinished.

1492: Leonardo paints The Virgin of the Rocks. He also designs elaborate armaments, among them a tank and war vehicles, as well as submarines and other battle engines.

1492: He draws remarkable plans for a flying machine.

1495: Leonardo begins work on The Last Supper, in the refectory of Santa Maria delle Grazie. The work is finished in 1498.

1496: Leonardo meets the mathematician, Luca Pacioli, with whom he studies the treatises of Euclid.

1499: The invasion of Milan by the French drives Leonardo to leave the city. He goes to Mantua, then to Venice, and finally to Friuli seeking employment.

Leonardo

1502: Leonardo begins work as a military engineer for Cesar Borgia, Duke of Romagne, son of Pope Alexander VI and General-in-Chief of his army. He supervises the building sites of the fortresses erected on the pontifical territories in central Italy.

1503: He becomes a member of the commission charged with finding a place worthy of the statue David by Michelangelo. His talents as an engineer are in great demand during the war against Pisa. He draws sketches for The Battle of Anghiari.

1504: His father dies on July 9th. There is a large inheritance, but Leonardo is swindled out of his share by the deception and trickery of his siblings. The death of his uncle soon afterwards revives the inheritance disputes; however, this time Leonardo wins out, receiving both the fortune and lands of his uncle. It is during this period that he begins to paint the Mona Lisa.

1506: He returns to Milan at the request of the French Governor, Charles d'Amboise. There he passionately studies the four elements: earth, air, water and fire.

1507: Leonardo is named painter of the court of Louis XII of France.

1514: The artist returns to Rome where he comes under the patronage of Pope Leo X. He is heavily inclined toward scientific discoveries. However, his fascination for anatomy and physiology is hindered by the Pope's insistence that he should not open corpses for study purposes.

1516: Leonardo's sponsor, Julio de Medici, dies on March 4th. He is then invited to France to enter the service of Francois I, as First Painter, Engineer and Architect to the King. He builds a mechanical lion on the occasion of the king's coronation. His new patron is extremely generous and Leonardo passes the last years of his life in the luxurious apartments of a manor located not far from the royal chateau of Amboise.

1518: The artist draws the plans for a palace at Romorantin.

1519: Leonardo da Vinci dies on May 2nd at Cloux, and is buried in the church of St Valentine in Amboise. He leaves all of his manuscripts, drawings and tools to his favourite student, Francesco Melzi. All of the paintings remaining in his studio, including Mona Lisa, are given to Salai, another student. It is said that the King, Francois I, stayed at Leonardo's side until the very last, cradling his head in his hands.

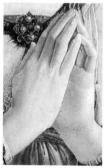

eonardo was born in 1452 on the right bank of the Arno in the town of Vinci between Florence and Pisa. His father was Ser Piero, who at that time was twenty-two or twenty-three years old. His mother was a young peasant girl named Catarina. One may well imagine the details of the little family drama that took place at the birth of Leonardo which put a brusque and prosaic end to his parents' romantic idyll. Ser Piero broke his vows with Catarina, at the urging of his father without a doubt, took his son with him,

The Virgin and Child with Two Angels

Leonardo da Vinci and the workshop of
Andrea del Verrocchio, probably 1470s
Egg tempera on wood, 96.5 x 70.5 cm
The National Gallery, London

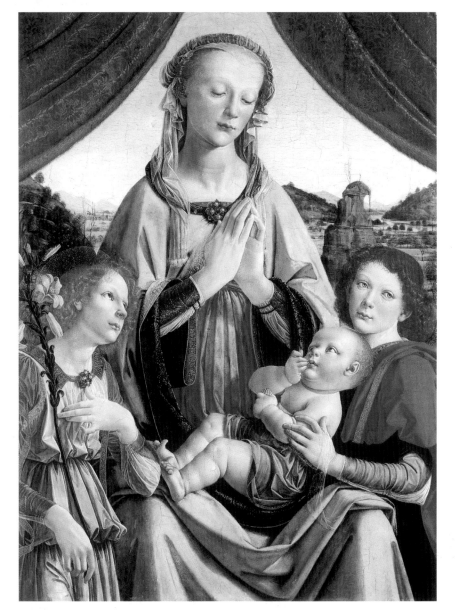

and that same year married Albiera di Giovanni Amadori. For her part, Catarina quietly married a certain Accatabriga di Piero del Vacca, a peasant who did not look too closely into her past. As an illegitimate son living with his father, Leonardo grew up without that maternal influence that every great man with self-respect should experience. Leonardo da Vinci spent his childhood in his father's house. Probably he was not made to suffer because he had been born out of wedlock,

Baptism of Christ

Leonardo da Vinci and Andrea del Verrocchio, 1470-1476
Oil and tempera on wood, 177 x 151 cm
Galleria degli Uffizi, Florence

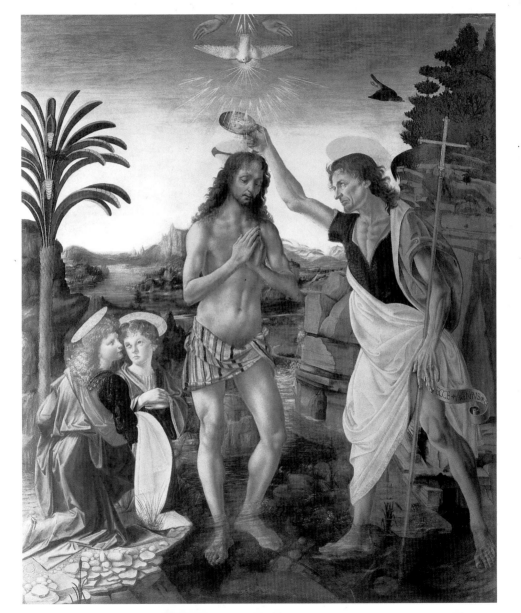

since it was his good luck that during his childhood no legitimate child was born to turn his stepmother's mistrust against him. We know very little about his early studies. He went from Vinci to Verrocchio's studio in 1470 at the latest, and, starting in the year 1472, his name is written in the register of the painters' guild as an independent member. Perugin and Lorenzo di Credi were his fellow students at the studio. This is the time when, with the divine gift of youth and an infinity of hope, the world opened up before him.

Virgin and Child (Madonna of the Carnation)

c.1473
Oil on wood, 62 x 47.5 cm
Alte Pinakothek, Munich

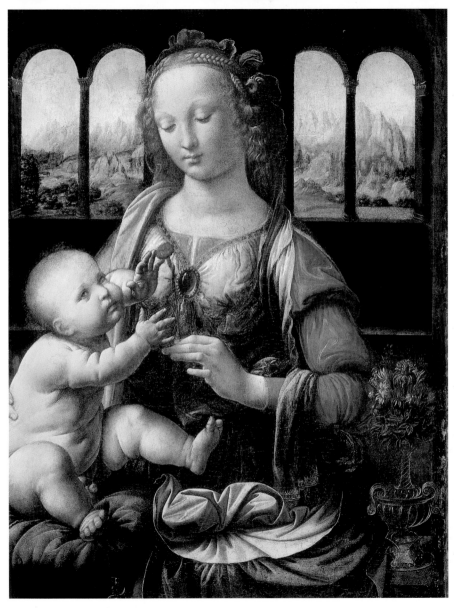

13

As an artist, from his very first works, he attracted all eyes, aroused the attention of his rivals and, if we can believe the legend, discouraged his master. Verrochio had received an order from the Vallombrosa monks for a *Baptism of Christ* and Leonardo contributed a kneeling angel to that painting. The figure should have been unnoticeable within the group work, but it stood out to such an extent that nothing else was noticed. Vasari tells the story that since the masterpainter was so "disturbed to see a child paint better than himself,

Study of Draperies for the Arm of an Angel in the Annonciation

c.1472
Pen and ink, 7.8 x 9.2 cm
Christ Church, Oxford

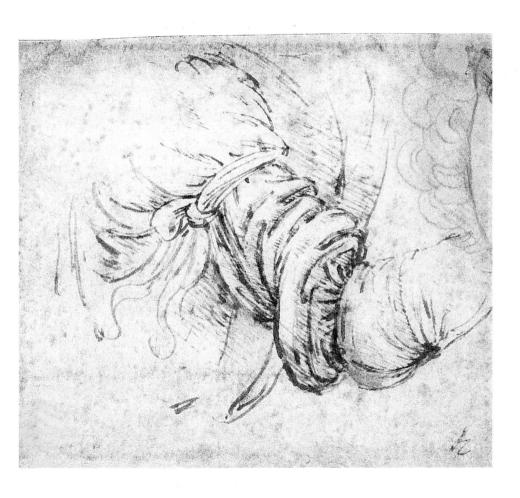

Verrocchio decided that from that day forward he would never again take up a brush".

During that first stay in Florence, Leonardo must have led a brilliant, and probably somewhat dissipated, existence. More than once his comic verve showed up at the expense of the stolid bourgeoisie of Florence. Almost all of Leonardo's first works have been lost. They are hardly known at all, except from the descriptions of Vasari.

Lily

———

1480-1485
Pen and ink, black chalk on paper, 31.4 x 17.7 cm
Royal Library, Windsor Castle

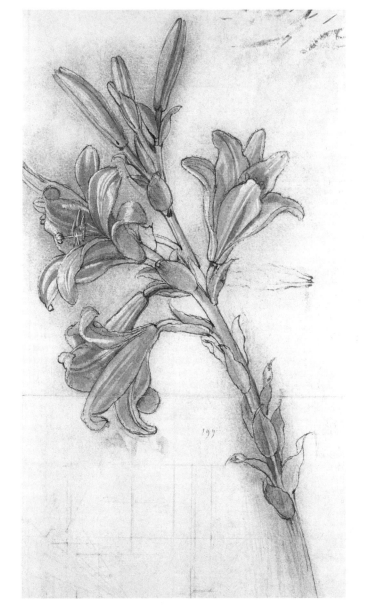

But those descriptions are enough to show us that from the beginning he had found his own identity as an artist. Already the scholar in him appears within the artist, studying nature's functions in order to use her methods in the human sphere like a machine that responds to one's needs, or a work of art that enriches the soul with the emotions it awakens. He already had the skill of composition, the science of *chiaroscuro*, the joyful attitude and the strength of expression which would make all of his contemporaries from Perugin (*Virgin,* in the museum in Nancy, *Virgin of the Rocks,*)

The Annunciation

1472
Oil on wood, 98 x 217 cm
Galleria degli Ufizzi, Florence

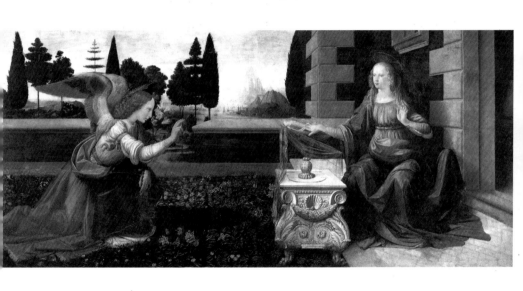

to Lorenzo di Credi, Michelangelo and Raphael, become – to a greater or lesser extent – imitators of Leonardo. One can sense the living spirit of da Vinci in his works as it moves from the soul to the body, from the inside to the outside, first imagining feelings, and then their expression in gesture and physiognomy.

By insisting on emotion, he defines it and varies its nuances. But, as a painter, he does not separate this from the movement that follows from it.

Arno Landscape

1473
Pen and ink, 19 x 28.5 cm
Galleria degli Ufizzi, Florence

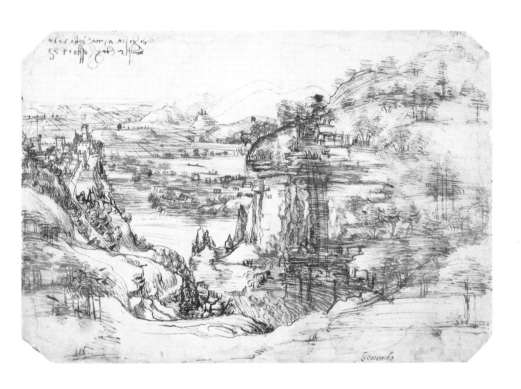

He sees it represented in the bodies it animates and he follows, with his impeccable hand, the lines moved by that ineffable shiver of inner life. If the scholar in da Vinci did not kill the artist, it is because, above all, he oved invention. He never asked of science more than the power it bestows to act and to create.

Already in this first period of his life, Leonardo was many things; a painter, a sculptor, an architect, an engineer and a scholar — in a word, a man who is a real man, whose actions flow in all directions.

Ginevra de' Benci

c.1474/1478
Oil on panel, with addition at
bottom edge, 42.7 x 37 cm
The National Gallery of Art, Washington, D.C.

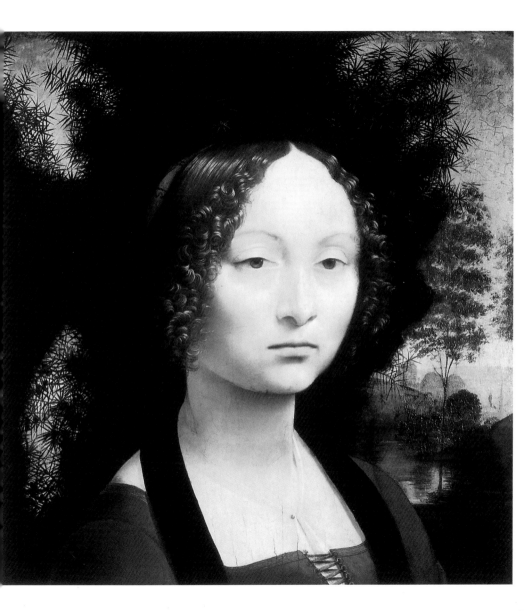

At thirty, Leonardo was in full possession of his talent. No longer the sublime child of the *Baptism of Christ,* he knew what he wanted and what he could do. He had method and he had genius.

His early successes gave him the highest aspirations. What was he missing? A free field of action, material power, money, everything that could turn his dreams into reality. Although he had been reproached for leaving Florence for Milan,

The Madonna and Child
(The Benois Madonna)

1478
Oil on canvas, 49.5 x 33 cm
Hermitage Museum, Saint Petersburg

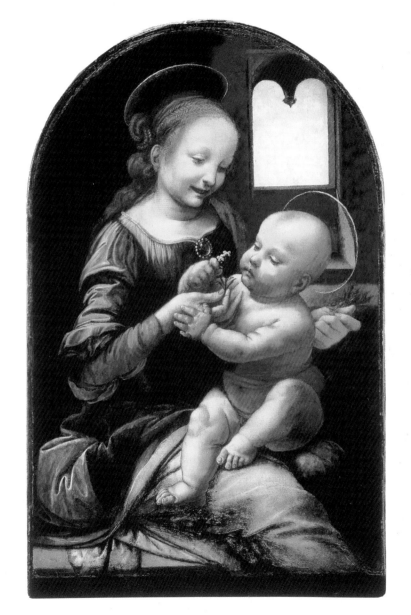

and Lorenzo da Medici for Ludovico Sforza, he went to Milan looking for what he would look for all his life, a prince who trusted in his genius and who would give him the means for action. Leonardo came to Milan seeking the opportunity to act and to exercise his universal genius. He could not have found anyone better than this prince who was avid for glory, curious about all the sciences and intent on justifying his usurpation of power by making

Virgin and Child with Cat

c.1478-1481
Pen and ink, 13 x 9.4 cm
British Museum, London

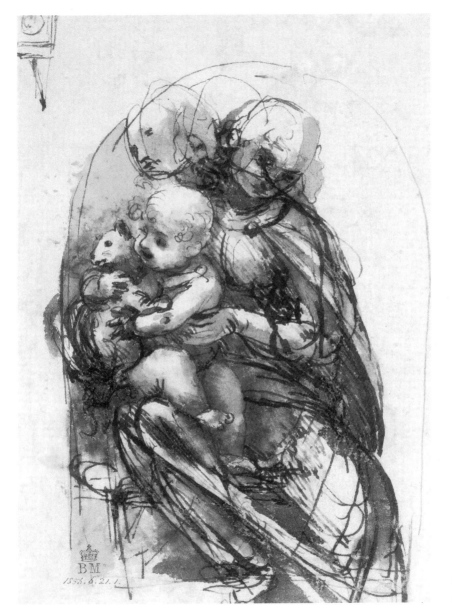

27

Milan the most important city in Italy and the rival of Florence. Leonardo was the man Sforza needed for this purpose. For the regent, the duke and the other noblemen, he organised fashionable shows, processions, triumphal scenes, and mythological pantomimes (*Perseus and Andromeda*, *Orpheus Charming the Wild Beasts*, etc.), and cleverly-directed allegories in which the symbolic characters seemed to float in the air. By employing beautiful forms and beautiful colours

Study of the Madonna and Child with a Cat

c.1478
Pen and ink, 28.1 x 19.9 cm
British Museum, London

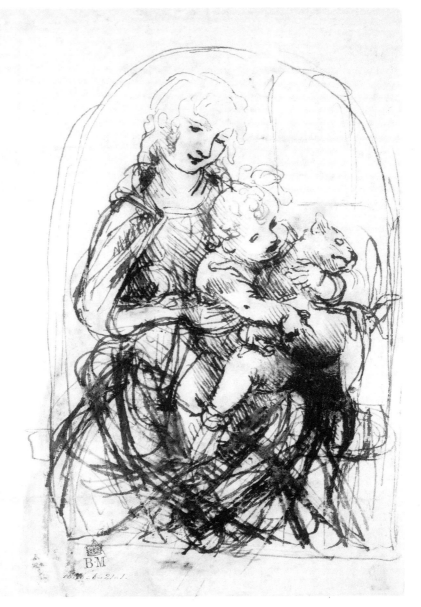

29

and using a harmony of refined sensations, all of these entertainments blended art with life. Leonardo designed the costumes, directed the troupes, designated the decorations for the characters, and invented ingenious tricks to enliven the shows.

But these roles of director and decorator were merely superficial games within the scope of his genius. While amusing himself by inventing ephemeral shows that reflected the vagaries of the changing moods and fashions of the great ladies of Milan,

Studies of a Dog's Paw

1490
Metalpoint on paper coated with a pale
pink preparation, 14.1 x 10.7 cm
National Gallery of Scotland, Edinburgh

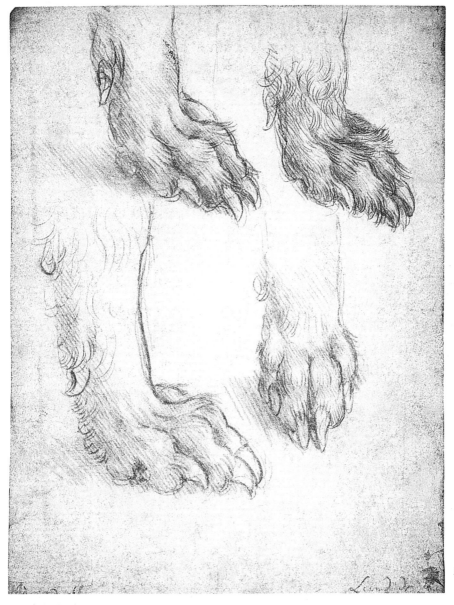

31

he worked on lasting works of art, which are, to this day, continually reborn and freshly renewed in the spirit of mankind. Leonardo's great work in Milan was *The Last Supper* (p. 83), which he painted in the refectory of the Santa Maria delle Grazie Church, working on it for many years, perhaps ten. He did not deign to use *trompe-l'oeil* in his paintings. He wanted his work to perfectly reflect "Nature" as it is seen by the human eye. One seems to enter this painting and see the actual table with those men seated behind it at the end of a long hall.

Bust of a Warrior in Profile

c.1475-1480
Silverpoint, 28.7 x 21.1 cm
British Museum, London

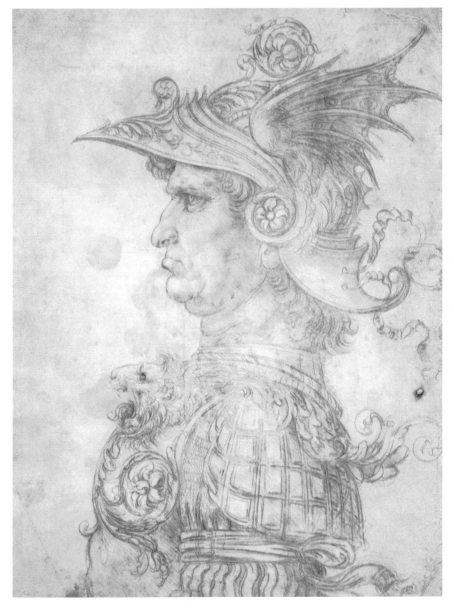

The master used his profound knowledge of perspective to achieve that effect. We have not yet exhausted the scope of Leonardo's activities. When speaking of him it is perfectly correct to say that, to him more than to any other man, nothing human was foreign or unfamiliar. In Milan, he was not only the court's party organizer, its greatest painter, and its greatest sculptor, but, together with Bramante, he held the title of *"ingeniarius ducalis"*. The word *ingeniarius* has the double meaning of engineer and architect.

Study of Flowers

c.1481-1483
Metalpoint, pen and ink, 18,3 x 21 cm
Galleria dell'Accademia, Venice

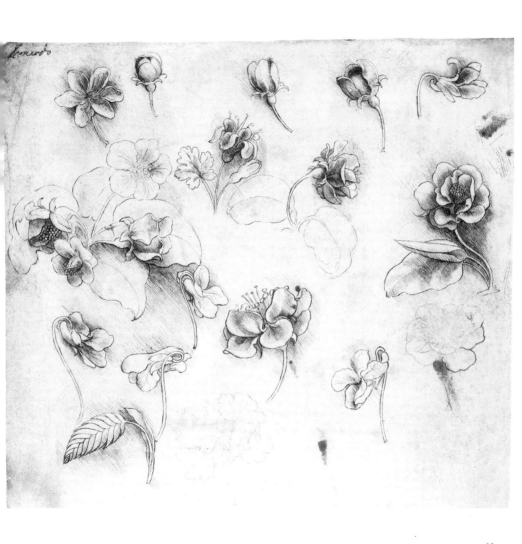

35

However, we know of no building of that period that was built under his direction or with his plans. But Leonardo was both an architect and a theoretician of architecture. According to the immutable laws of his spirit, he travelled from art to the science that it implies. Reflection was never very far from action for him because he directed reflection immediately towards the ability to act upon it. The curiosity of the scholar within him was simply the ambition of a man who passionately studies the laws of nature in order to surpass them as he imitates them.

Perspectival Study for Adoration of the Magi

c.1481
Pen and ink, traces of silverpoint and
white on paper, 16.3 x 29 cm
Galleria degli Uffizi, Florence

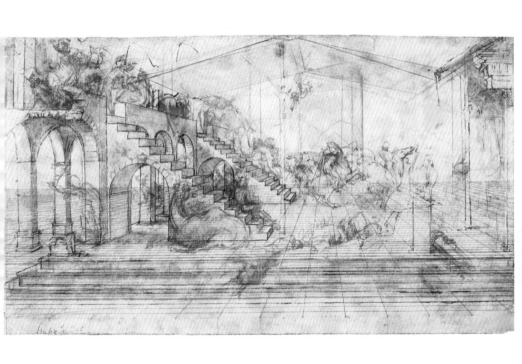

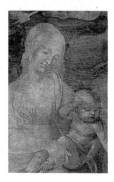

He studied the cracks in walls, their causes, and their remedies: "First, treat the causes which lead to breaks in the walls, and then separately treat these ills." He studied the nature of the arch, "which is nothing other than a strength caused by two weaknesses", and then the laws that must be observed in the division of the load it bears, the relations of the foundation to the building it must support, and the resistance of the beams. Involved as he was in the construction of great religious buildings,

Adoration of the Magi

1480
Tempera mixed with oil with parts in red or greenish lacquer, and white lead, 243 x 246 cm
Galleria degli Ufizzi, Florence

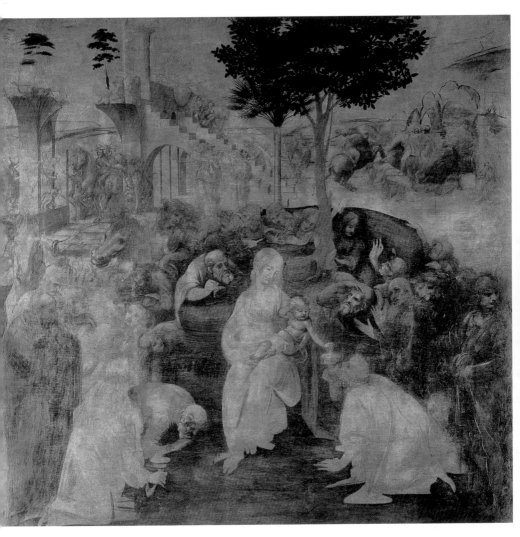

such as the cathedrals of Pavie and Cuomo, the cupola of Milan Cathedral, and perhaps Santa Maria delle Grazie, he was led to reflect on the nature of religious architecture. Whatever the influences that he may have felt, or acted upon, Leonardo, the architect, always remained himself. He kept his taste for veracity, his disdain for fantasy, and that high level of reasoning which first of all accepts what is necessary. But science directed his ambition without lessening it in the process.

Saint Jerome Praying in the Wilderness

1482
Unfinished painting in a mixed technique of oil and tempera on walnut wood, 102.8 x 73.5 cm
Musei e Gallerie Pontificie, Vatican

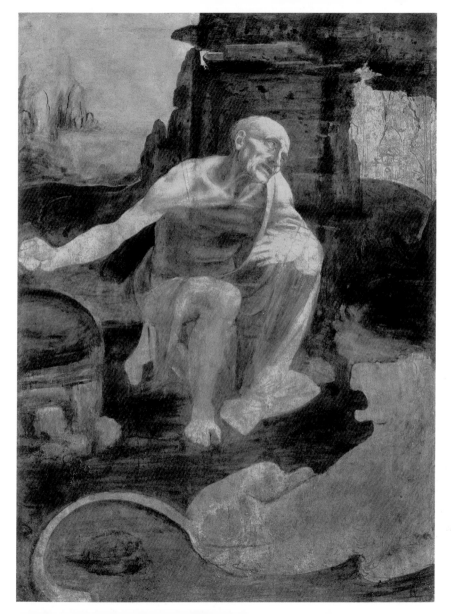

41

The spirit of the scholar was for him at the service of his imagination as an artist, and the same laws that limited the dream allowed it to be fully realised. As an engineer, he undertook to build an entire system of canals which were designed to regulate the flow of the rivers that criss-cross Lombardy. He opened new routes of commerce, and by making water readily available everywhere, he made the countryside a healthy and fertile place.

Portrait of Cecilia Gallerani, The Lady with the Ermine

1483-1490
Oil on panel, 54.8 x 40.3 cm
Czartoryski Museum, Krakow

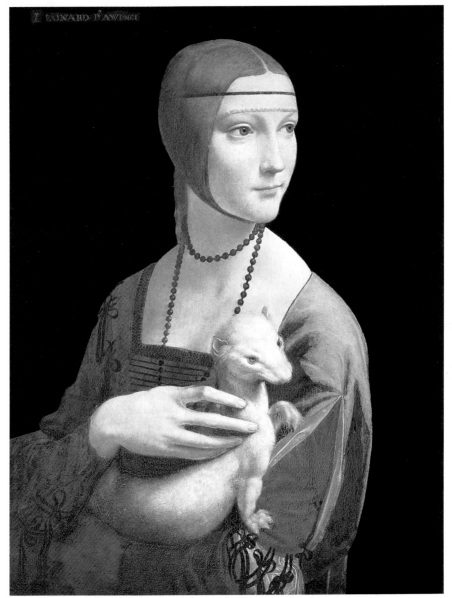

As we cross the rich plains of Lombardy, furrowed by the streams that irrigate them, and marvel at their beauty stretching under the golden sunlight all the way to the Alps, whose blue masses and silvery summits are silhouetted against the sky, we must thank Leonardo. He understood the nature of water, and he knew well the damage that it could cause having thoroughly studied its nature, its currents, and its laws of movement, so that he could make it obey him and submit it to his intelligent will.

Portrait of a Musician

c. 1485
Oil on wood, 43 x 31 cm
Pinacoteca Ambrosiana, Milan

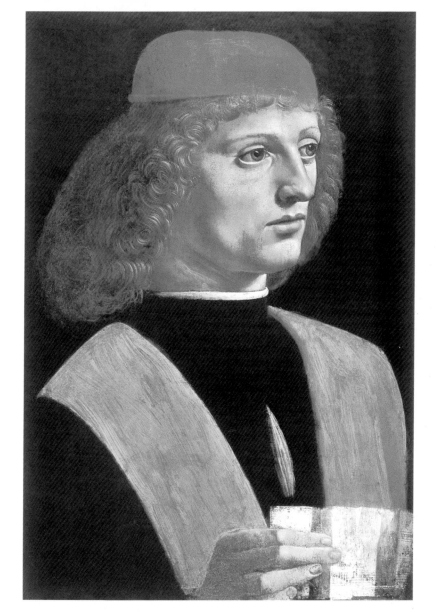

He gives, and then takes back, and then follows it as it strays, so that men may more fully profit from it.

"The water of the Adda is greatly diminished by the Martesana canal, being distributed over many lands for irrigation of the fields, and, being of no use to anyone, is carried to nobody. Here is a remedy: create many reservoirs which gather the water that is soaked up by the earth and is of no use to anyone. Thanks to these reservoirs, the water that was lost will again be of use to men."

Studies of Churches with Central Nave Plans

1485-1490
Ms B. fol.17v
Institut de France, Paris

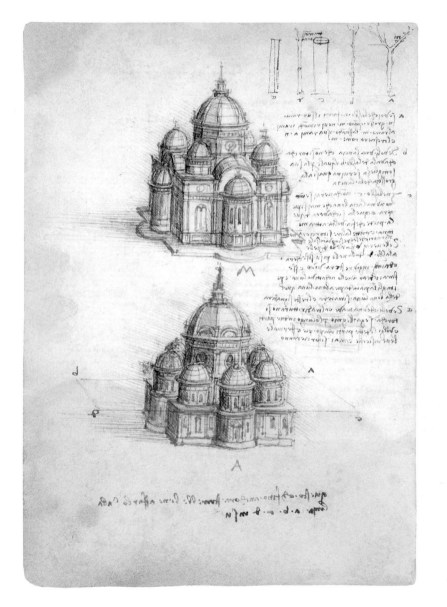

47

Genius is beneficent without effort, and its generosity lies in that it can enjoy these riches only when they are shared. These great endeavours, which really were just aspects of his multi-faceted life, were seen by one and all. But perhaps more surprising was his inner activities, that invisible and constant effort of his soul in the service of both truth and beauty. His attention was perpetually alert, and for him everything was an occasion for research and discovery.

A Rider on a Rearing Horse Trampling a Fallen Foe
(Study for the Sforza Monument)

1485-1490
Metalpoint on blue prepared paper, 15.1 x 18.8 cm
Royal Library, Windsor Castle

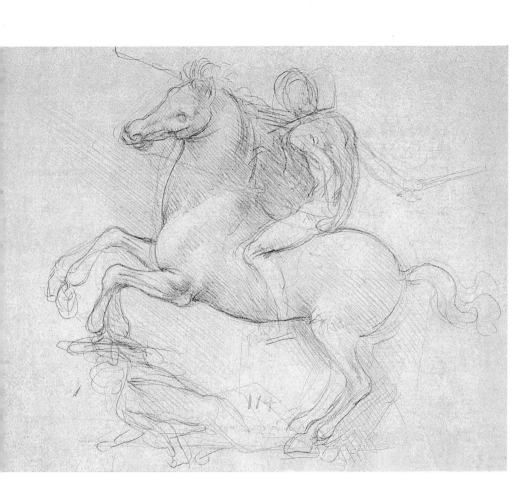

His contemporaries, who saw him at parties mixing with the ease of a gentleman in the brilliant life of princes, could hardly suspect the unceasing activity that we find in his manuscripts. Practice led him to theory, action to science, and the little notebooks he always carried with him are filled with both ingenious and profound ideas which were born spontaneously within his mind. To the story of his life should be appended the history of his thought.

Grotesque Profile of a Man

c.1485-1490
Pen and ink, 12.6 x 10.4 cm
Biblioteca Ambrosiana, Milan

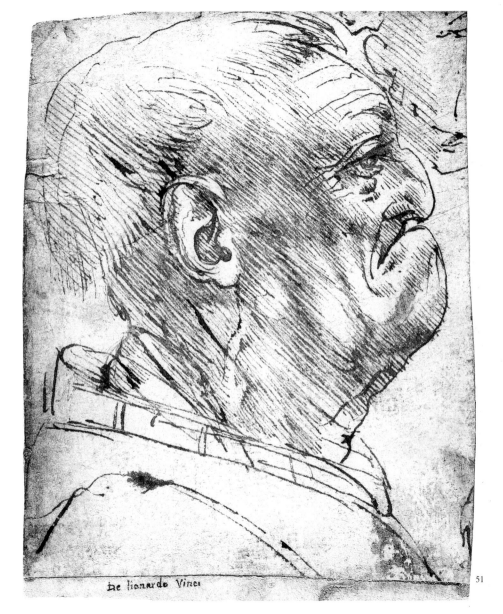

de lionardo Vinci

51

In his letter to Ludovico il Moro, which serves as an introduction to *Divine Proportion,* Luca Pacioli, after speaking of *The Last Supper* (p. 83) and da Vinci's equestrian statue, adds:

"These works do not deplete him; having already quickly achieved a knowledge of beauty in painting and human movement, he took on another inestimable task, one concerning rhythm, weight, and accidental forces or strengths." Elsewhere in his introduction, Pacioli tells us that the Duke brought together "in a worthy and scientific duel" preachers,

Interior of the Skull

1489
Pen and ink, 19 x 13.3 cm
Royal Library, Windsor Castle

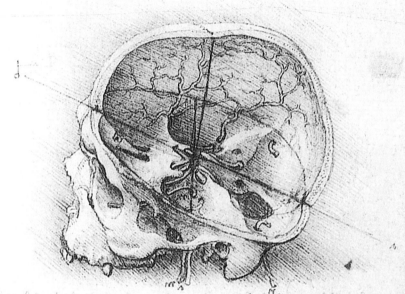

jurists, theologians, architects and engineers – all the illustrious experts in every imaginable field, so plentiful in his magnificent court. He mentions Leonardo da Vinci among them. To Ludovico's credit, (according to this text) on the eve of his defeat, and in the midst of political difficulties of every kind, on 9 February 1499, he gathered all the scholars in his court to his chateau and attended to their works. In the British Museum there exists an engraving attributed to Leonardo, which seems both firm and inexperienced at the same time.

The Skull Sectioned

1489
Pen and ink, 19 x 13.3 cm
Royal Library, Windsor Castle

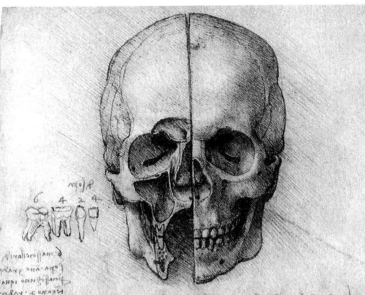

55

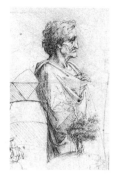

It encircles the following inscription: *ACHA:LE:VI:* - an abbreviation of *Academia Leonardi Vincii.* We find that curious mention on a marker covered with complicated lines and arabesques framing the words *Academia Leonardi Vincii.* One might suppose that these labels are connected to the meetings of scholars which Ludovico held and over which Leonardo presided, but this hypothesis seems doubtful.

Various Studies

before 1490
Pen and brown ink, 32 x 44.5 cm
Royal Library, Windsor Castle

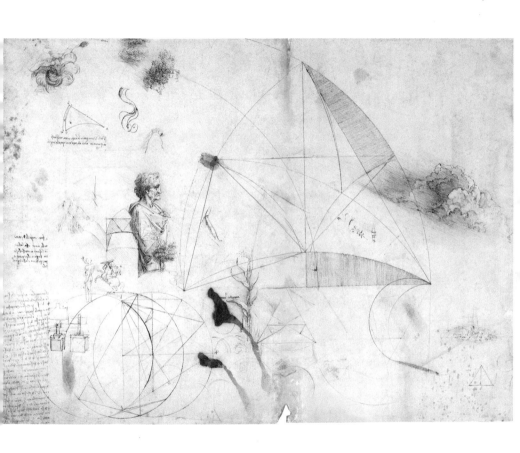

57

As with Raphael later, Leonardo had several disciples who lived under his roof. One could be tempted to believe that the Academy consisted, in addition to his disciples, of all those attracted to his genius and his goodness, the variety of his acquaintances and the charm of his personality. It is hard to say what the teachings of such a master would have been. Whatever freedom there might have been, given his taste for exactitude, it could not have been vague and general.

A Study of a Woman's Hands

c.1490
Silverpoint, white highlights on pink
prepared paper, 21.5 x 15 cm
Royal Library, Windsor Castle

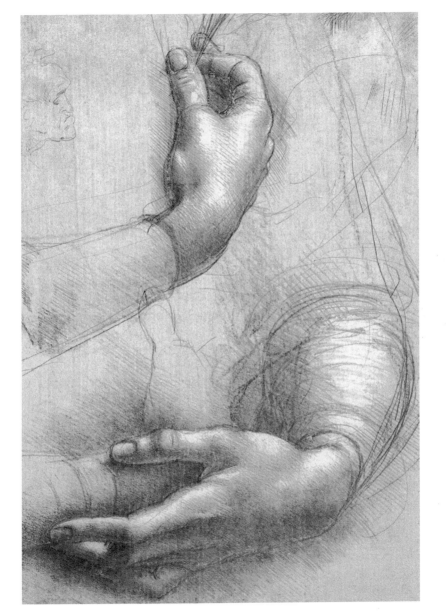

It should be said that in his manuscripts he often addresses an imaginary interlocutor, in order to describe an experiment or a plan of observation. Thus, the "grand inventor of new things" created more than objects; he created minds and spirits, animated by his own life force. The sixteen years that Leonardo spent at the court of Ludovico were the happiest and most productive of his life. He had left the intensity of his youth in Florence.

Study of a Head of a Woman

c.1490
Metalpoint on paper, 18 x 16.8 cm
Musée du Louvre, Paris

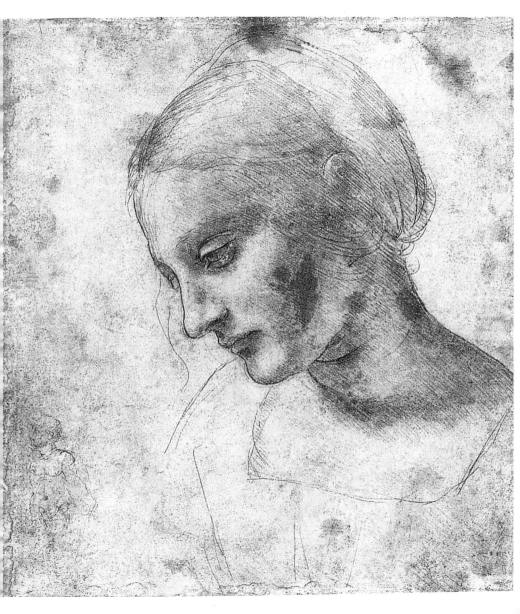

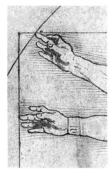

Brilliant, already admired, and still curious, he arrived at Milan at thirty, a grown man sure of his genius and avid for science and for action. He improvised while accompanying himself on a silver lyre; his grace immediately conquered hearts. The audacity of his universal genius had aroused the curiosity and ambition of Ludovico il Moro, and da Vinci was, therefore, welcomed everywhere. The entertainments he created were the most brilliant and beautiful of the time.

The Vitruvian Man

1490
Pen and ink, 34.4 x 24.5 cm
Galleria dell'Accademia, Venice

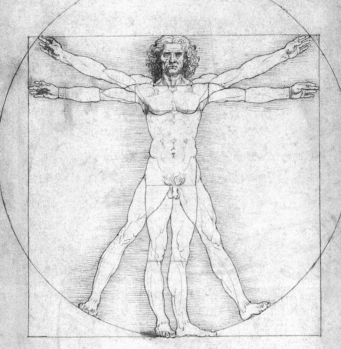

63

The prince's mistresses all wanted their portraits painted by him. He had more than fame: he had that direct and immediate success that went beyond his due as an artist. The prince's favour gave him, above all, an opportunity to do great things. During his preparations for an entertainment at the castle he dreamed of *The Last Supper* (p. 83), the equestrian statue, and the cathedral of Pavie; he meditated on the course of the Adda,

Portrait of a Lady from the Court of Milan, wrongly called the Beautiful Ferronniere

1490-1495
Oil on wood, 63 x 45 cm
Musée du Louvre, Paris

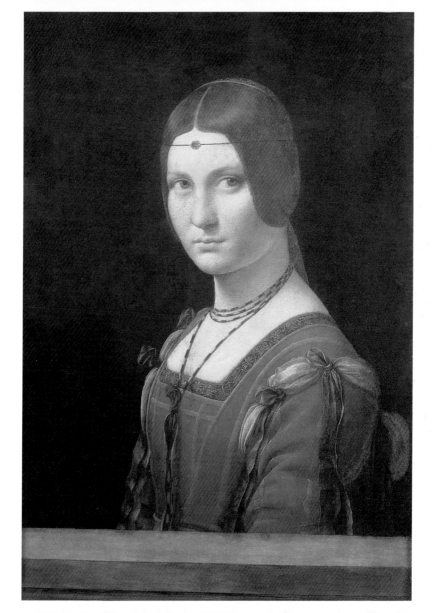

and between two orders, he jotted in his notebook an idea that had just suggested itself to him from an observation he alone had made. He always loved Milan, and always returned there willingly, but that did not mean that he did not suffer there. For instance, he never had the pleasure of seeing the statue which he had worked on for so long finally cast in bronze.

At first, his appointments were paid quite regularly. But very soon Gualtieri,

The Virgin of the Rocks (The Virgin with the Infant Saint John adoring the Infant Christ accompanied by an Angel)

about 1491-1508
Oil on wood, 189.5 x 120 cm
The National Gallery, London

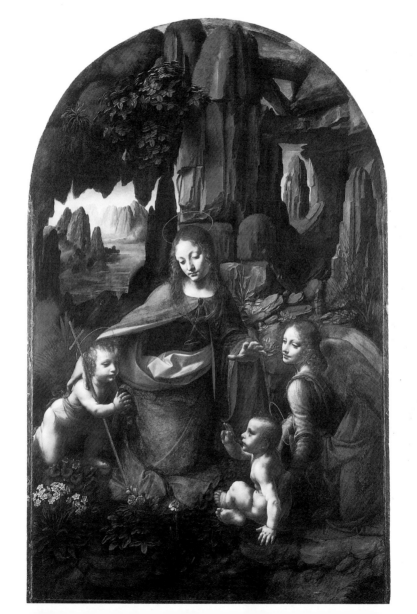

the treasurer, 'forgot' about the artists in order to attend to other expenses; Leonardo was reduced to complaining. He was in need and forced to make a living:

"He had to interrupt the work that His Lordship had entrusted to him, to dedicate himself to works of lesser importance; but he hoped soon to have earned enough money to be able to satisfy His Excellency by making up his labours with a clear mind. He fed six men for fifty-six months, and for this received fifty ducats."

Half a Male and Half a Female Body

c.1492-1493
Pen and ink, 27.3 x 20.2 cm
Royal Library, Windsor Castle

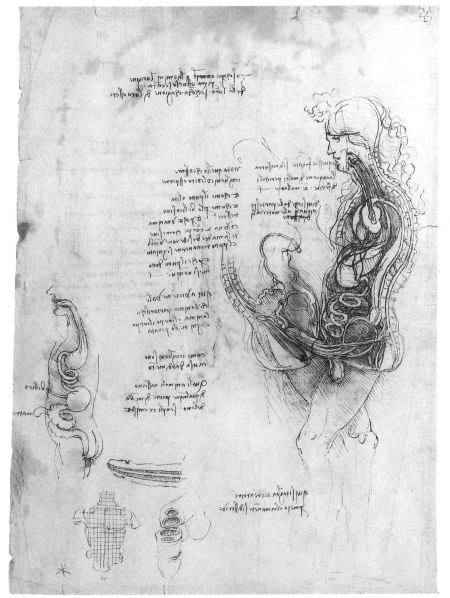

69

Did this letter remain without a response? On this torn piece of paper, where only half of every line is legible, a mere draft of a letter in which it is easy to guess at what is missing, we see this great artist as a humiliated man who is discouraged and reduced to soliciting what he was due.

It was a hard profession, that of a man of genius. Leonardo's best years were past. He was almost fifty years old.

Coupling Study

1492-1494
Pen and ink, 28.5 x 20 cm
Royal Library, Windsor Castle

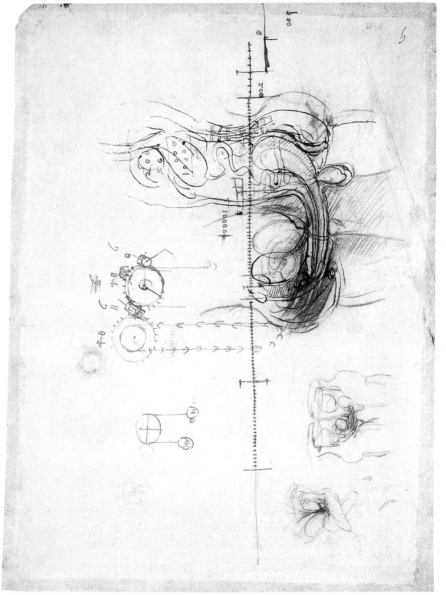

He would have been happy just to finish the works he had begun: the equestrian statue, the Milan canals, and the vast encyclopaedia of which he accumulated elements until his last days. Sadly, his destiny from then on was to be unable to settle anywhere. He was not a maker of paintings but a jack-of-all-trades. He needed a powerful protector, one who, would share his highest ambitions while respecting his independence. The uncertainties of Italian politics made for a chaotic life.

A Rocky Ravine

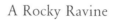

c.1475
Pen and ink on pink paper, 22 x 15.8 cm
Royal Library, Windsor Castle

73

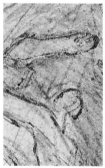

When he was supported by a prince, bad fortune would befall his patron. Marignan finally gave him Francois I and the land of France where he could die, and, although sad, at peace with himself.

It was no longer possible for Leonardo to remain in Milan, which was governed by Trivulzio, and in the hands of soldiers. In March 1500, during the brief interregnum of Ludovico il Moro, we find him in Venice, where his stay was to be short.

Bust of an Apostle with Right Hand Raised

c.1495
Pen over metalpoint on blue prepared paper, 14.5 x 11.3 cm
Albertina Museum, Vienna

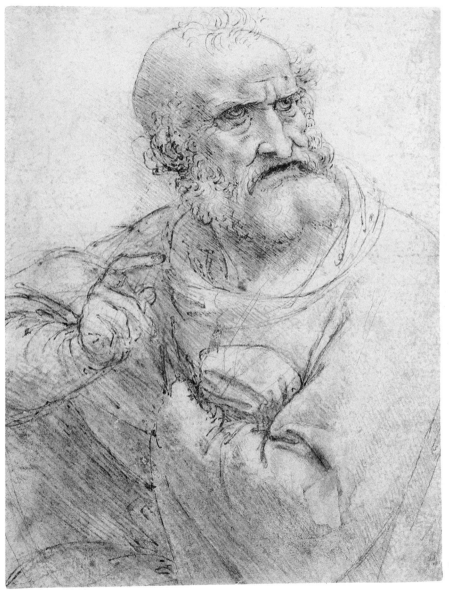

75

In 1501 Leonardo appeared in Florence. This was his home country; he was no stranger there. During the sixteen years that he lived and worked in Milan he had returned to Florence more than once, but he never enjoyed the democratic, agitated city, which was divided into violent parties whose petty hates left him indifferent.

When he returned in 1501, Florence had barely recovered from the jolts that had shaken the city.

The Head of St Phillip

c.1495
Black chalk, 19 x 15 cm
Royal Library, Windsor Castle

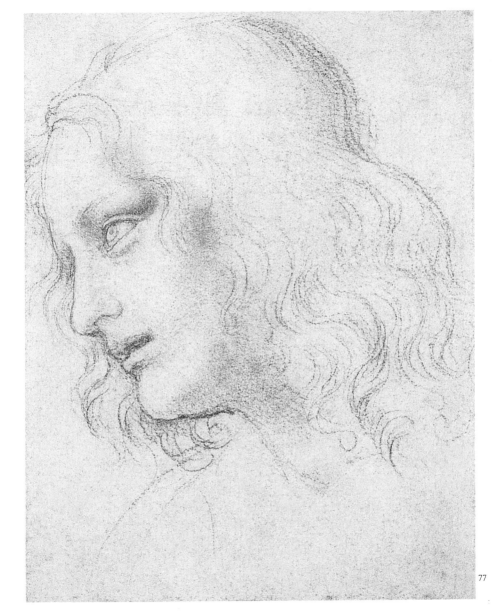

Savonarola had expiated his dreams of political and religious reform on his funeral pyre (1498) and his death saddened many hearts. Fra Bartholomew became a monk in the monastery of San Marco; Lorenzo di Credi, despairing at the death of this prophet, renounced painting entirely; Sandro Botticelli, the melancholic and charming artist (whose name is the only one mentioned by Leonardo in his *Treatise on Painting*, where he called him 'friend'),

Study for The Last Supper (Christ)

c.1495
Pastel and charcoal, 40 x 32 cm
Pinacoteca di Brera, Milan

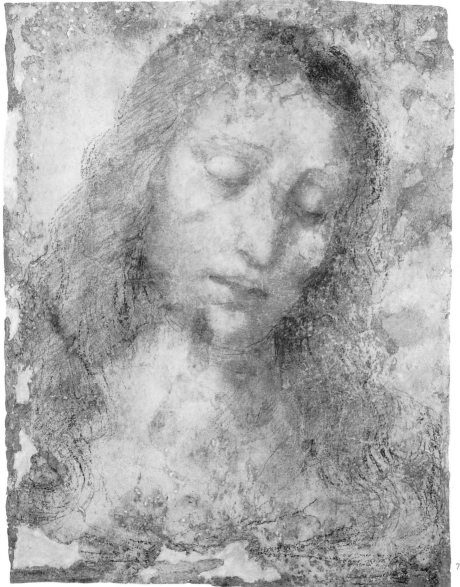

could not awaken from the passionate dream that the ardent eloquence of the martyr had evoked in him, and buried himself in his commentary on, and the illustration of, the writings of Dante. Later, Michelangelo, under the arches of the Sistine Chapel during his long hours of solitary work, would reread the sermons of Savonarola. Leonardo had other things on his mind than the homilies of a monk whose hollow dreams were repugnant to his lucid intelligence.

The Head of Judas

c.1495 or later
Red chalk, 18 x 15 cm
Royal Library, Windsor Castle

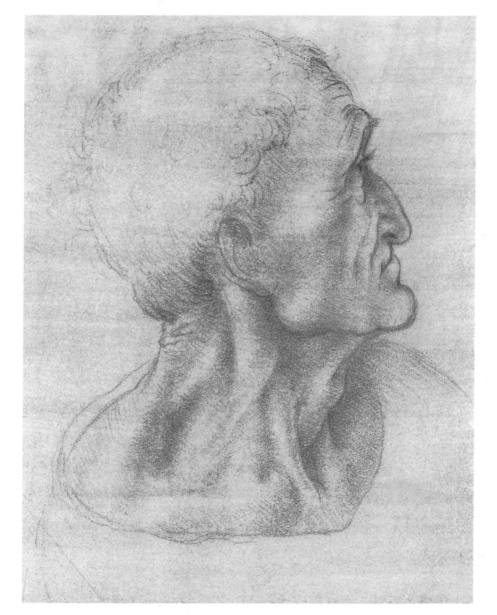

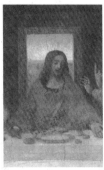

He knew that one does not carry out ideals by attacking and detaching from the physical world, but conquers them day by day through slow effort, relying on all the forces of one's intelligence concerning the realities there below. It was at this time that Isabelle of Gonzague tried to attach Leonardo to her service. Isabelle, sister of Beatrice, was one of the most distinguished women of the Renaissance and her name is linked to those of all the celebrated men of her time.

The Last Supper

1494-1498
Tempera on gesso, pitch, and mastic, 460 x 880 cm
Santa Maria delle Grazie, Milan

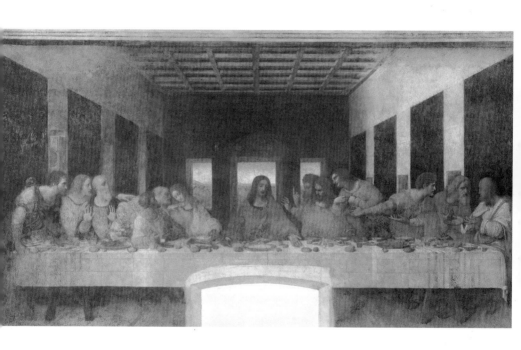

She was grateful to artists for the attention they gave her, and her delicate flattery was expressed in the manner in which she addressed them. Her knowledge of having a position in the society which shaped, however inconspicuously, the noble spirit of the time, gave her a charming modesty. She dreamt of erecting a statue of Virgil at Mantua, and she asked Mantegna to execute this project. Corregio and Titian worked for her.

Saint Anne, the Virgin with the Child and Child John the Baptist

1499-1500
Black chalk and touches of white chalk on brownish paper, mounted on canvas on tinted paper, 141.5 x 104.6 cm
The National Gallery, London

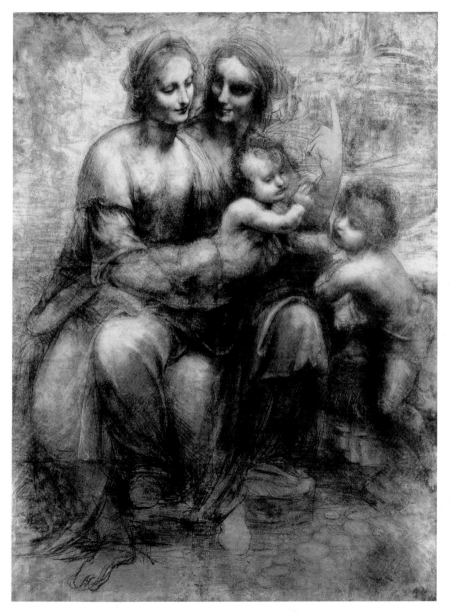

Bembo, Bandello, Arioste, and Tasse all dedicated works to her. She would receive from Leonardo, at the very least, kind words and promises.

Independence meant, for Leonardo, the freedom to exercise all of his faculties at once and on his own schedule; he needed a protector whose needs were as varied as his talents. Isabelle did not give up. In 1502 she ordered her agent in Florence to consult with a 'competent man' such as the painter,

Studies for the Christ Child

1501-1510
Red chalk, brush and red wash (head at center), small traces
of white gouache highlights over traces of stylus
on ocher-red prepared paper, 28.5 x 19.8 cm
Galleria dell'Accademia, Venice

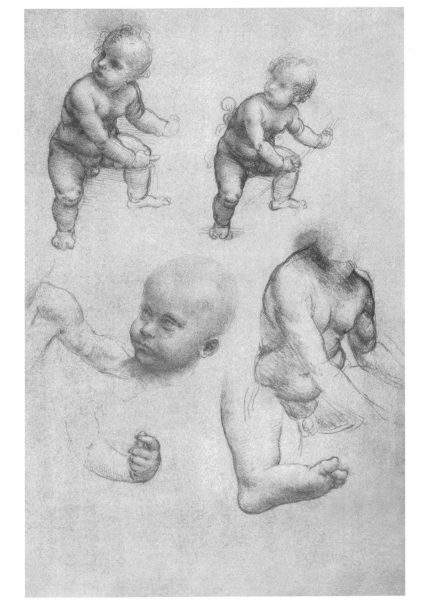

Leonardo, who, according to his own words, was her friend, concerning certain vases she wished to buy. On 24 May 1504, she wrote to Leonardo in her own hand:

"On learning that you are in Florence, we had hoped to obtain that which we have so long desired: something by your hand. When you were here and drew my portrait in charcoal, you promised me a painted copy."

A few days later Isabelle's agent wrote to her that he had seen Leonardo, and that he would try again with him and with Perugin.

Head of Dishevelled Young Girl, or La Scapagliata

1500
Burnt umber and green umber and highlights
of white on wood, 24.7 x 21 cm
Galleria Nazionale, Parma

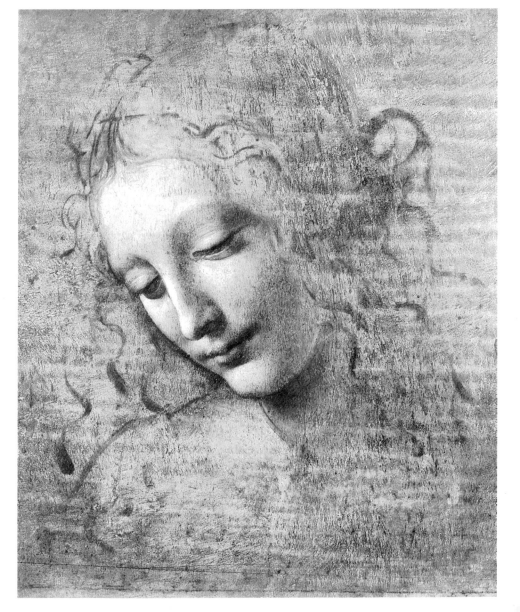

"Both one and the other have promised, and appear to have a great desire to be agreeable to Your Ladyship, but I fear they will compete in slowness. And I don't know which of them will win over the other in that, but I am almost certain that Leonardo will be the winner. For my part, I will be extremely diligent with both of them."

Did Leonardo begin some sketches for *Jesus among the Doctors?*

Portrait of Isabella d'Este

1500
Black and red chalk, yellow pastel, 61 x 46 cm
Musée du Louvre, Paris

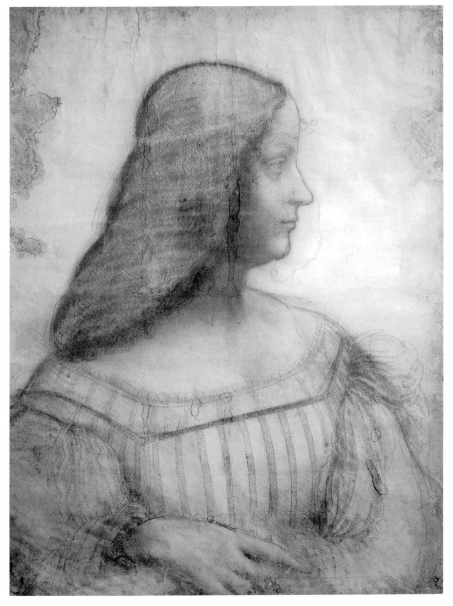

Did he also have a hand in the picture recently attributed to him at the National Gallery, and in the fresco of Luini at Sarrono? We do not know, but the amiable lady never got the work she requested with such delicacy and goodwill. When Louis XII triumphantly entered Milan in 1499, Cesar Borgia from France was riding at his side. There is no doubt that he met Leonardo at this time and, struck by his genius, hoped to bring him into his service one day.

Map of Tuscany and Emilie-Romagne

1502-1503
Pen and sepia, 31.7 x 44.9 cm
Royal Library, Windsor Castle

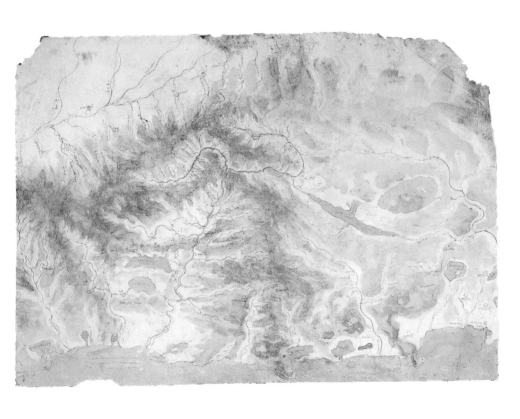

Louis XII soon found that he had to terminate the engagements he had made with Leonardo in favour of his ally. Cesar was at that time the most powerful prince in Italy and it only remained for him at that point to organise what he had conquered in order to justify his success and excuse his crimes. Leonardo was just the man for a prince with such great ambitions. In Leonardo's notes one can follow the itinerary of his travels through central Italy as Cesar's engineer.

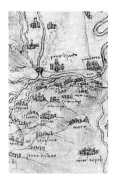

Map of Western Tuscany

1502-1505
Pen and ink on black chalk, 27.5 x 40 cm
Royal Library, Windsor Castle

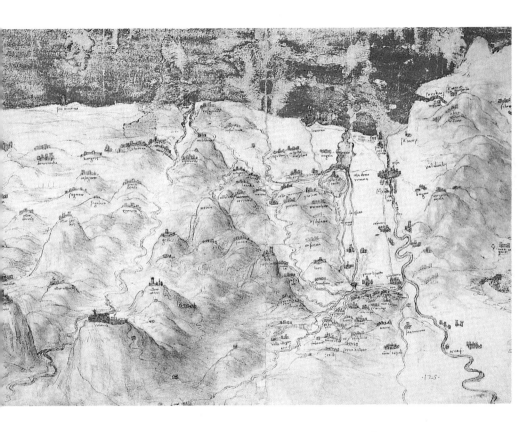

On July 30th he passed through Urbino, where he designed a dovecote. Forty days earlier Cesar had taken the town by the most infamous of treasons. He borrowed artillery and troops from the Duke of Urbino, to whom he was allied, to hold a garrison in Romagne, after which he took and destroyed the defenceless town, killing its inhabitants and pillaging the castle and the riches which the Duke had accumulated there.

A Scheme for a Canal to Bypass the Arno

c.1504
Pen and ink on black chalk, 33.5 x 48.2 cm
Royal Library, Windsor Castle

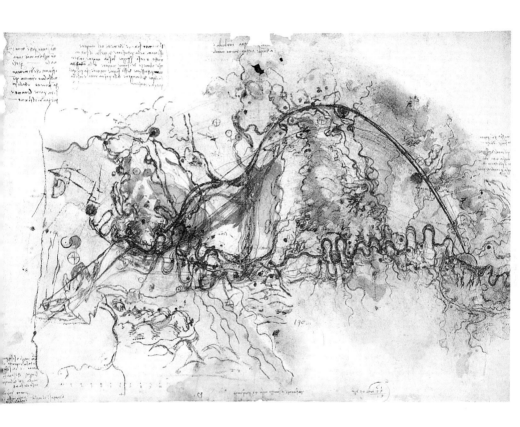

190 m

97

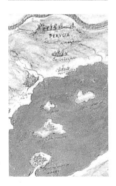

On 1st August Leonardo was on the shores of the Adriatic at Pesaro, where he visited the library and designed several machines. From Pesaro he followed the coast northward to Rimini, which he reached on August 8th. There he studied its reservoirs and water distribution system. On the 11th he was at Cesena, where he remained until the 15th. There he sketched a house crowned with battlements and pierced with openings,

Map of the Val de Chiana

1504
Pen and sepia with blue and green wash, 42.2 x 24.2 cm
Royal Library, Windsor Castle

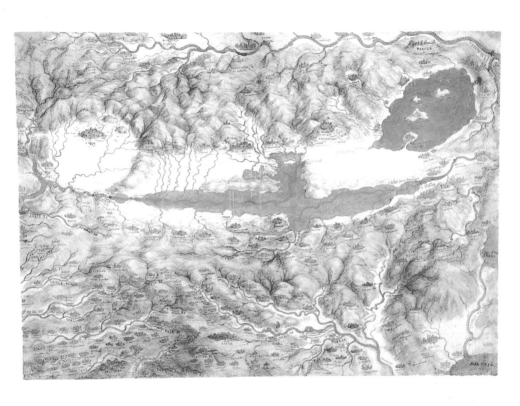

a real fortress; he also described both a carriage, and a cultivating procedure for vineyards being used in the countryside. On 6th September we find him near Ravenna, at Cesenatico. There he designed the gate, and described the best way to arrange the beams in order to ensure its defence from all sides.

Notable among his drawings at Windsor is a small map of Imola which includes the city and its defences.

A Cannon Factory

c.1503-1504
Pen and dark brown ink over traces of black
chalk or leadpoint (?), 24.7 x 18.3 cm
Royal Library, Windsor Castle

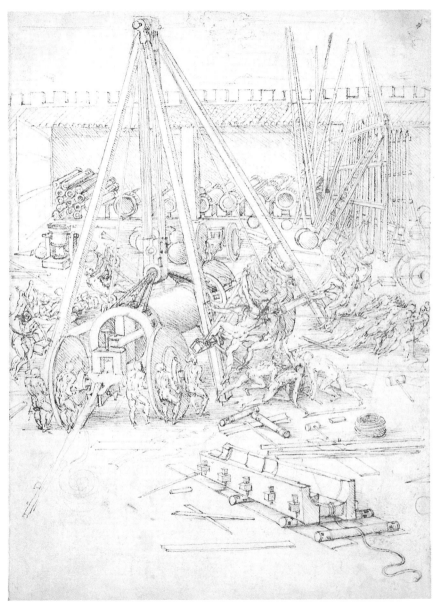

101

This map is enclosed in a circle traced with the middle of the city at its centre and arrows showing the compass directions. A note attached to the map indicates the different locations surrounding Imola (Bologna, Castel san Piero, Faenaz, Forli, etc.), as well as the distances separating them. We know that at the beginning of October 1502 a sudden revolt of his *condottieri* forced Cesar to fortify himself in Imola, where he was under siege for several weeks.

Studies for the Heads of Two Soldiers in the "Battle of Anghiari"

1503-1504
Charcoal, or soft black chalk; some traces
of red chalk on left, 19.2 x 18.8 cm
Szépmüvészeti Múzeum, Budapest

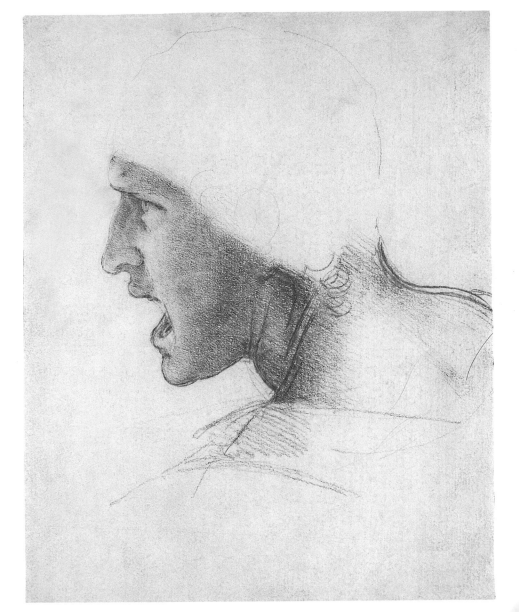

At that time Leonardo was surely with him, and the map of Imola was undoubtedly drawn to serve in the defence of the plaza or to indicate the best means of escape. In this time of tension he wrote in the notebook he carried with him: "Fear is born more quickly than anything else." Louis XII finally intervened, negotiating a truce between the Duke and the rebels. But Cesar never forgot anything.

Study for the Head of a Soldier in the
"Battle of Anghiari"

1503-1504
Red chalk on very pale ocher-pink prepared paper;
outlines long facial profile slightly incised, 22.7 x 18.6 cm
Szépmüvészeti Múzeum, Budapest

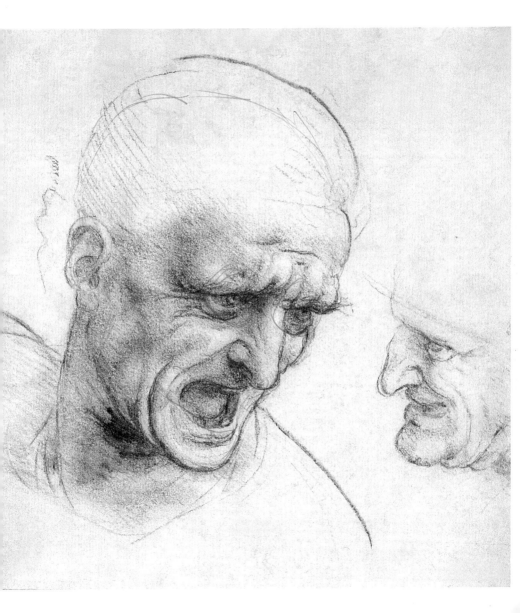

In December the *condottiereri* invited Cesar to enter Sinigaglia, which they had just taken for him. He rewarded them by having their throats slit at a banquet. Nevertheless, Leonardo continued his travels northward, passing through Buonconvento to Casanova, and from there to Chiusi, Perouse and Foligno. At Piombino, facing the island of Elba, he studied the movement of the waves, and searched to determine the laws by which they broke onto the shore.

Portrait of Mona Lisa del Giocondo
(The Mona Lisa)

1503-1506
Oil on wood, 77x 53 cm
Musée du Louvre, Paris

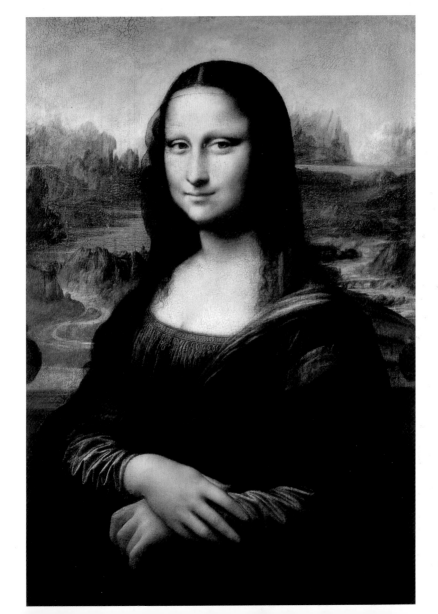

At Sienna he made a drawing of a peculiar bell tower. Orvieto, to the south, is the farthest point described in his notes. During this trip he gave himself over to whatever attracted his curiosity, as was his habit. But his maps of the different regions of central Italy, which are now at Windsor, attest to the patient and constant work he did at that time. These maps are admirable; in them, science and art are combined.

The Head of Leda

c.1505-1506
17.7 x 14.7 cm
Royal Library, Windsor Castle

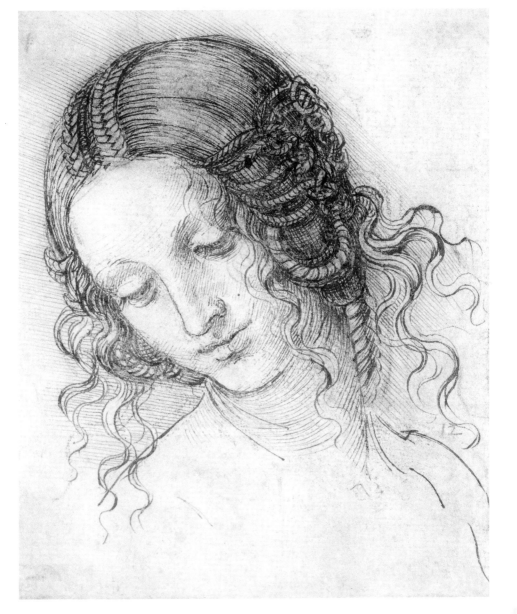

One finds there that genius whose thought reduces none of its innate grace, and that privileged eye which captures every detail, without ceasing to perceive relationships and the unity.

The ramifications of the water's flow, the direction imposed on that flow by the structure of the landscape, the many obstacles formed by mountains, the outflows that create valleys, and all the apparent results of chance,

Kneeling Leda and the Swan

c.1505
Pen and brown ink, brush and brown wash,
over charcoal or soft black chalk, 16 x 13.9 cm
Chatsworth, Devonshire Collection

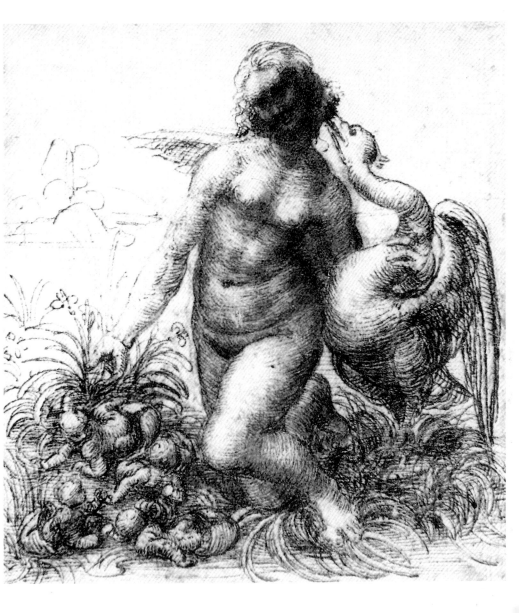

are incorporated in the needs of a scholar who perceives cause and effect, and are then rendered by the artist with a precision and freedom that gives these maps something of the beauty of a vast landscape, caught in a single glance. The most remarkable of these maps is the one whose perimeters are, to the north, the Ema valley near Florence, to the south, the Bolsena lake, extending east to Perouse and Cortone, and west to Sienna and the coast.

Kneeling Leda and the Swan

c.1505
Pen and brown ink (with losses of pigment), over extensive charcoal or soft black chalk; traces of a framing outline in pen and brown ink, 12.6 x 10,9 cm
Museum Boijmans Van Beuningen, Rotterdam

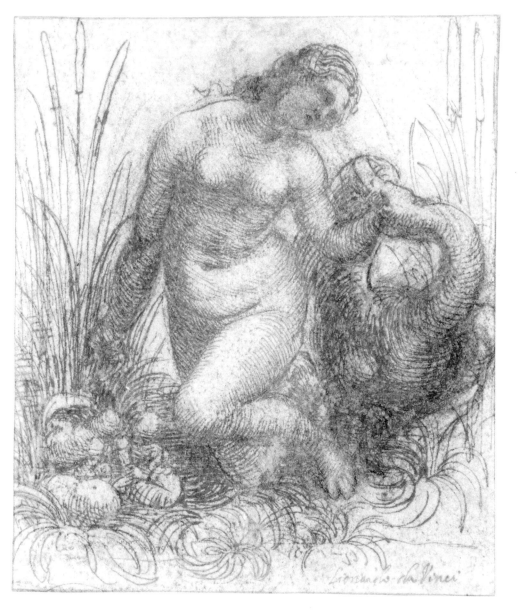

These maps were no doubt ordered from Leonardo by Cesar Borgia, and some, such as the one of the region between Lucques and Volterre, were specifically made to serve his strategic plans. By 1503 Cesar was in Rome. The wealthiest cardinals had all died one by one, and the Pope's coffers were full. But by August 18th, both perhaps caught in traps of their own making, Pope Alexander VI had died and Cesar was deathly ill.

Leda and the Swan

After Leonardo da Vinci, 1505
Oil on canvas, 132 x 76 cm
Galleria Borghese, Rome

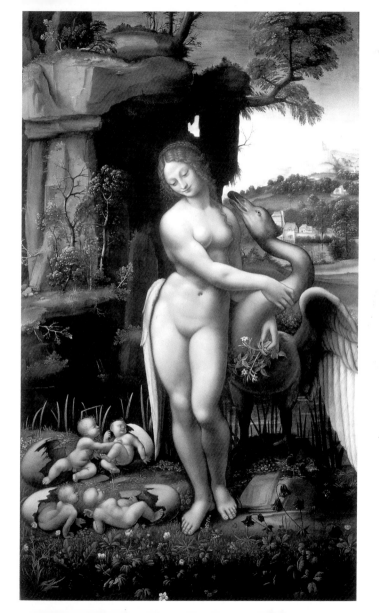

The latter had foreseen everything except this circumstance in which everything would be lost. He left Italy to die an adventurer's death in Spain. So many crimes for nothing; this phrase summarises the result of the rogue politics that would seduce Machiavelli, and would make the romantics swoon. Treachery should not go so far beyond the limit as to kill all confidence in a common humanity. The greatest politicians mostly speak the truth, in order to be better able to lie on occasion.

Various Studies

before 1508
Pen and ink, 24 x 17 cm
Royal Library, Windsor Castle

117

Leonardo was able to compose one of his fables on this theme; in it he showed the deceiver as the deceived, and the ruse, by unforeseen circumstances, causing the one who had too subtly conceived it to be destroyed himself.

Was his employment by Cesar meant to be of indefinite duration? Was it brusquely interrupted by the fall of the Borgias? Who knows. What is certain is that in 1503 he returned to Florence.

Botanical Studies with Star-of-Bethlehem, Grasses Crowfoot, Wood Anemone, and Another Genus

c.1505-1508
Red chalk, reworked with pen and dark brown ink, 19.6 x 15.8 cm
Royal Library, Windsor Castle

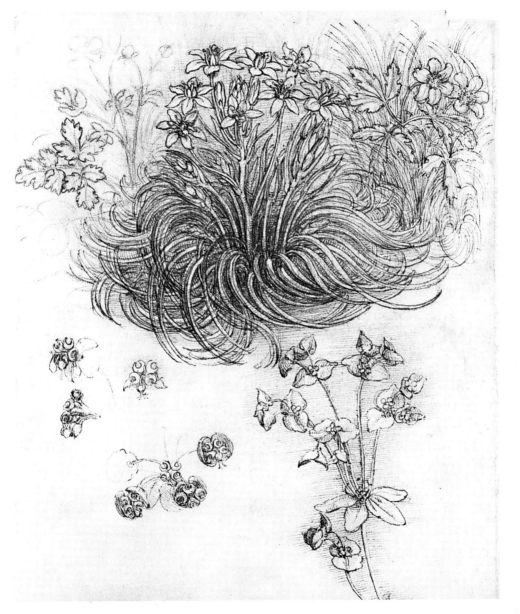

In that year, and the one following, his name is found in the account book of the painters' guild of that city.

Michelangelo was about thirty and already famous. At the end of the year 1503 he had finished his David, *David the Giant*, carved from a block of marble that earlier had been spoiled by an ignorant sculptor. On 20 September 1504 an assembly of artists and state deputies was called to discuss the location where the statue should be erected.

A Storm in an Alpine Valley

c.1508-1510
Red chalk, 19.8 x 15 cm
Royal Library, Windsor Castle

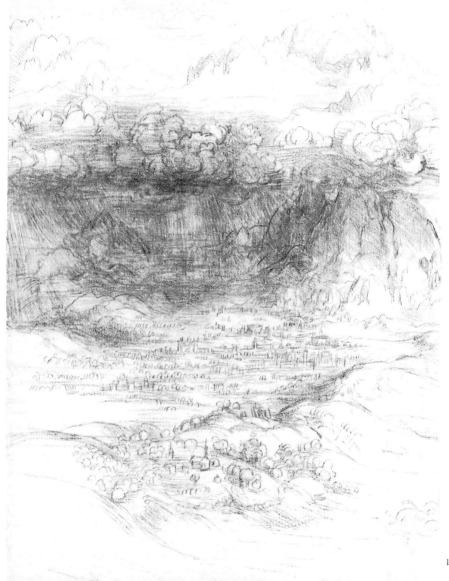

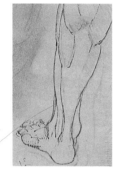

Leonardo spoke in eleventh place and seconded the opinion of Juliano da San Gallo who had proposed that it be placed under the Loggia dei Lancei. Michelangelo detested his great rival. He hated in Leonardo what he could neither understand nor love. Impatient with reality, his ferocious platonic soul uncomfortable with our puny bodies, Michelangelo created grandiose forms which, shaped by his passion, had both its quiver and its force.

Comparative Studies of Human and Horse Legs

c.1506-1508
Pen and brown ink, brush and brown wash over traces of red chalk on ocher or brick-red prepared paper; 28.4 x 20.4 cm
Royal Library, Windsor Castle

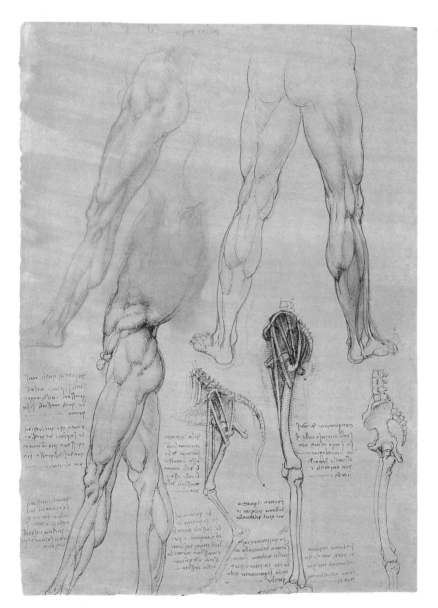

123

He had the heroic tenderness of the strong; he wanted to impose his dream on the world. Leonardo was pleased by the sort of metamorphosis that joined his life with that of the material world; his mobile heart followed his curious mind and found a thousand opportunities for love. For him, the ideal was not illusion; he did not understand anger but saw the world with patience and kindness, and he gave himself to it in order to conquer it.

Study of Horses' Hind Legs

c.1508
Biblioteca Reale, Turin

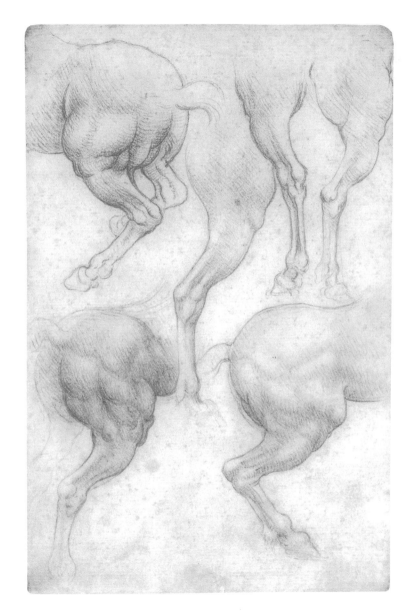

Michelangelo could not tolerate this impenetrable and charming soul. Leonardo's serenity seemed egotism to him, and his exquisite realism a diminution of art. Like Dante, Michelangelo was passionately patriotic; he never ceased to see the image of his friend, Savonarola, lost to the flames of a pyre for the crime of wanting good for humanity. Leonardo's indifference to these iniquities, and his voluntary nonpartic-ipation, made Michelangelo indignant.

Study for an Equestrian Monument

1508-1511
Black and red chalk, 21.7 x 17 cm
Royal Library, Windsor Castle

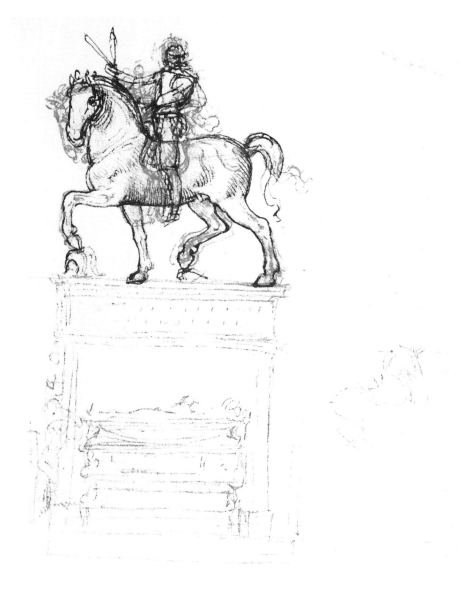

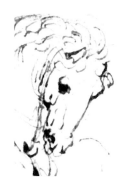

Leonardo had become the most famous painter in Italy, yet there was still no work of his in Florence, to honour his native city. He was then given a commission, together with Michelangelo, to decorate the Council Hall in His Lordship's palace. Their rivalry excited the general public, impassioned the friends of both artists and did not help to ease their relationship. Michelangelo chose a scene from the war with Pisa: bathing soldiers surprised by the enemy.

Study for the Trivulzio Monument

1508-1511
Pen and bister, 28 x 19.8 cm
Royal Library, Windsor Castle

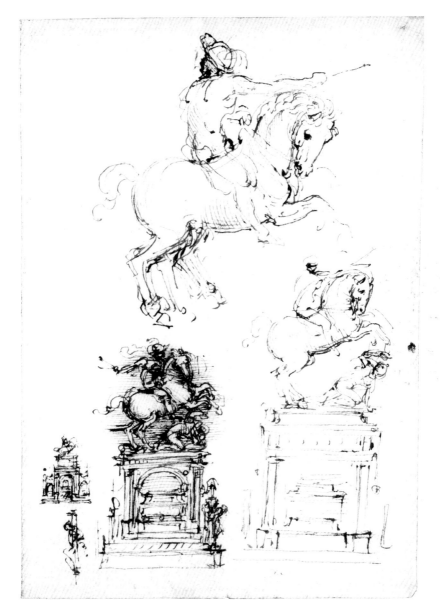

129

Leonardo, so long a guest in Milan, was to treat the battle of Anghiari, which had been won by the Florentines against the Milanese on 29 July 1440. Was this subject imposed on him by the Gonfalonier, Pier Soderini, a good friend of Michelangelo? Whatever the case, he went to work energetically. He was given the Pope's hall at Santa Maria Novella as a studio, and he worked on the cartoon from October 1503 until February 1504.

Nude Study

c. 1508-1511
Royal Library, Windsor Castle

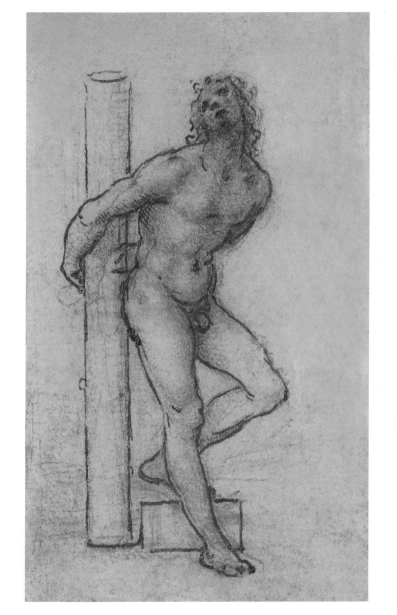

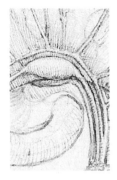

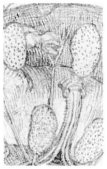

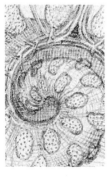

When the cartoon was completed, he began painting the mural in earnest in the Council Hall. In May 1506, he abandoned it. Only the episode of the standard as described by Vasari, which occupied the centre of the composition, was finished. We do not find any account by Leonardo himself of this incident which so curiously mixes precise details with fantasy. He did not choose any particular episode from the battle of Anghiari,

Cow Uterus
───────────
c.1508
Pen and ink, 19 x 13.3 cm
Royal Library, Windsor Castle

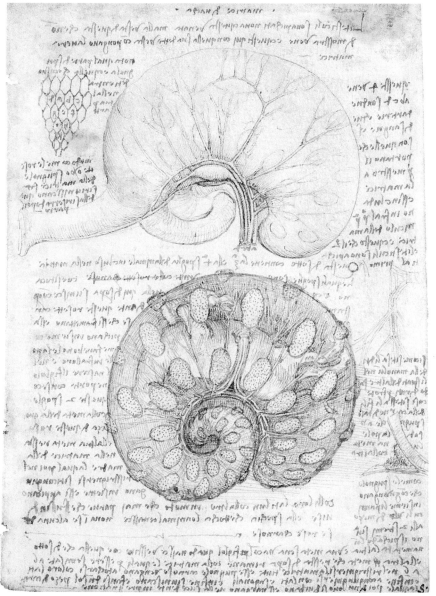

but that does not mean that he was content with a vague, general vision. He did not want a decoration, a mere operatic battle; he painted the real war, the "evil war", as the Italians called it to distinguish it from parades of *condottieri*. Here, as always, what characterised his work was his passionate search for truth. Whether as an artist or a scholar, he called primarily upon concrete experience; he first filled his eyes and his mind with clear images.

Cardiovascular System

c.1508
Pen and ink, 19 x 13.3 cm
Royal Library, Windsor Castle

Almost certainly, he had seen a few cavalry combats in northern Italy: he had been in Milan when the French invaded, and had perhaps been under siege at Imola with Cesar. He had attended manoeuvres and troop movements, and it was enough for him to focus on these images, modifying and amplifying them, to see the brutality of the fray. The idea is thus the only reality multiplied in its intensity by the spontaneous action of the mind which ignores that which is useless and centres itself on the expressive force.

The Organs of Women

c. 1509
Pen and ink over charcoal and traces of red chalk
with nutbrown wash, 46.7 x 33.2 cm
Royal Library, Windsor Castle

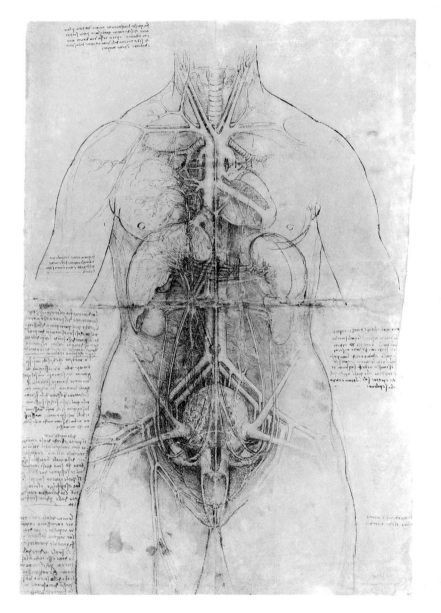

137

A fragment from Leonardo's *Treatise on Painting* entitled "How a battle should be represented" can serve as commentary on the few drawings remaining for us to see. It is not merely the details of the cartoon but the full spirit of the final work which he was looking for in its effects. What he says to the painter in this text, he has said to himself. The images on which he bases his description are those he evokes, and more than one of these is found among the sketches.

The Madonna and Child with the Infant Baptist, and Heads in Profile

———————————

c.1478
Pen and ink, 40.2 x 29 cm
Royal Library, Windsor Castle

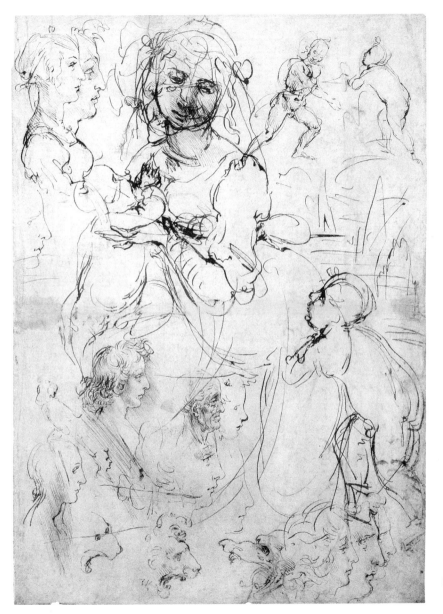

139

These pages, whatever else has been said about them, have the value of a confidence shared: the drawings surprise us with their verve and freedom of expression. They show that attentive study in preparation and subtlety of observation which, imitating reality in all its complexity, allow for the reproduction of the finest nuances. In anything he undertook, Leonardo was an innovator, and his originality, perhaps because it is authentic, is as precious as it is fertile.

St Anne, Mary and the Christ Child

c.1508
Pen and brown ink, 16.4 x 12.8 cm
Musée du Louvre, Paris

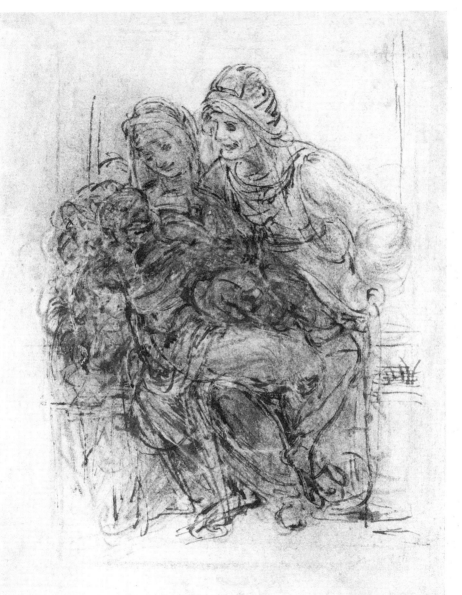

Not only does it bring something inimitable into the world, it also enriches the human spirit with what it possesses of the universal. He plays with the human machine with the same confidence; he understands the necessary connections which impetuous actions entail. His sketches are a marvel of life, confidence and audacity. In his portraits, as in his Madonnas, we sense the depth of grace, the delicate refinements, and the artistry in the rendering of the subtleties of an exquisite soul on a face.

Head of the Virgin

1508-1512
Soft black and red chalks, 20.3 x 15.6 cm
The Metropolitan Museum of Art, New York

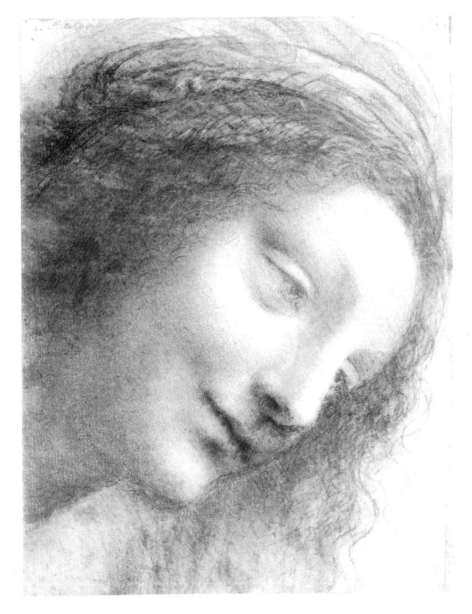

But his curiosity reaches all mankind. He wanted painting to have the power to evoke all human emotions. He liked the bizarre, the terrible. He went to see criminals hanged. This translated into a language of expressive symbols, ranging from the infinite tenderness of his Madonnas to anger, rage, despair, and the eagerness to kill; all of these stand out in his work. Da Vinci's ambition was to render everything which, on a face and in a figure,

The Head of St Anne

c.1510-1515
Black chalk, 19 x 13 cm
Royal Library, Windsor Castle

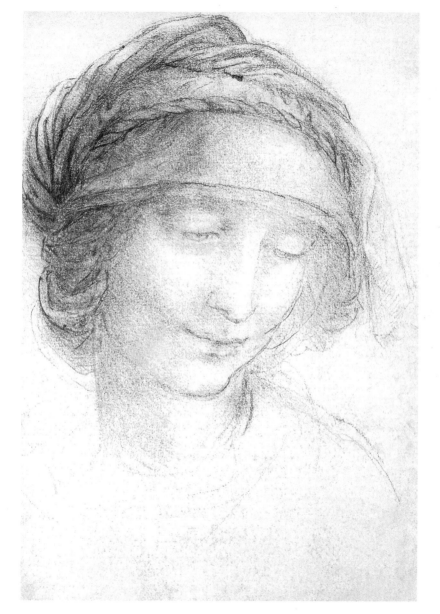

shows the human soul: The smiles of the noblewomen of Florence as well as the grimaces of ferocious soldiers. A portrait by him was a favour given. Sure of not being disappointed, the most beautiful women loved to grant him the task of securing their passing beauty in an image which would make it immortal. He brought to these works his patience, his concern for truth and that curious tenderness which communicated to him, as well as did the character of his models, the secret of their grace.

The Virgin, Christ Child and Saint Anne

1510
Oil on wood, 168 x 130 cm
Musée du Louvre, Paris

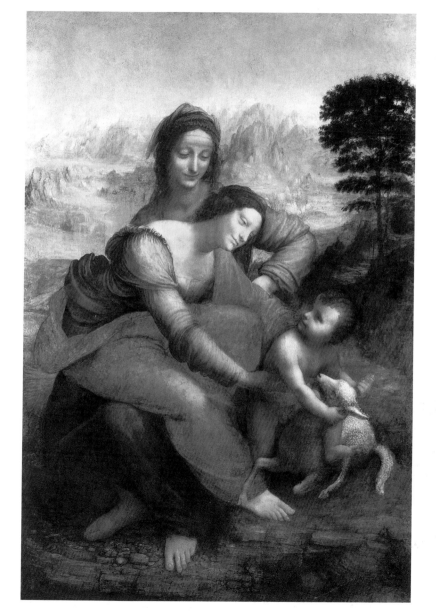

147

While they posed, he wanted them to be smiling and peaceful. In order to allow the full flower of their beauty to blossom, he lavished his incomparable talent for conversation on them, and had them listen to the best musicians of the city.

He enlivened their faces by charming their spirits and summoned their souls into their faces by lulling them with gentle emotion and capricious thoughts.

The Bust of a Man, Full Face,
and the Head of a Lion

c.1505-1510
Red chalk and white highlights on paper, 18.3 x 13.6 cm
Royal Library, Windsor Castle

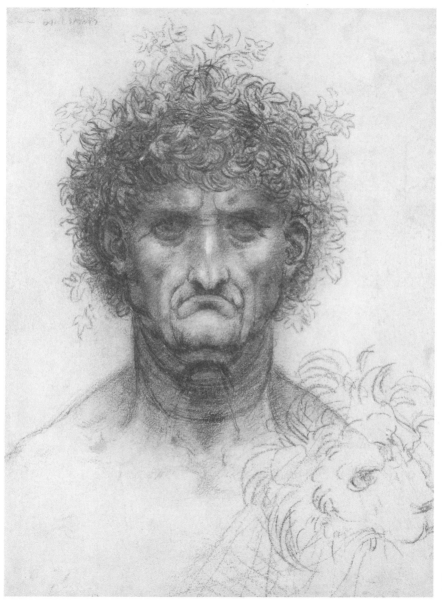

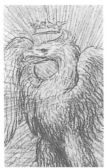

He painted a portrait of Amerigo Benci's wife Ginevra, whose charming head is to be seen on the Ghirladanjo fresco.

In 1501 he also finished the *Mona Lisa* (p. 107). The daughter of Antonio Maria di Noldo Gherardini, Mona Lisa was from Naples, the third wife of Aznobi del Giocondo, whom she had married in 1493. This portrait, which he worked on for four years, became immediately famous. The model was sin-gularly patient.

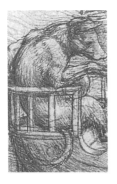

Allegory of the Wolf and the Eagle

c.1510
Red chalk on greybrown paper, 17 x 28 cm
Royal Library, Windsor Castle

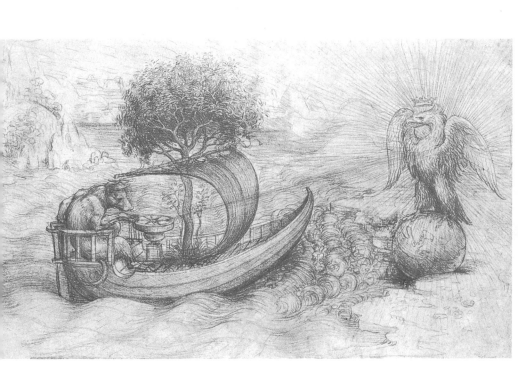

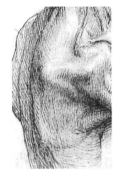

If this shadowy portrait exerts a sort of fascination, if so many young men have stood thoughtfully in front of it, the question is this: does this image of a woman, as seen by the soul of her lover, contain the troubling charm of the desire she evokes? That the beauty of the *Mona Lisa* (p. 107) and Leonardo's exquisite tenderness penetrated each other in this work, there is no doubt. Should one believe in a romance between them? Perhaps the response should remain vague so that each person can choose an answer as they wish.

The Surface Anatomy of the Shoulder

c.1510-1511
Pen and ink with wash over charcoal, 28.9 x 19.8 cm
Royal Library, Windsor Castle

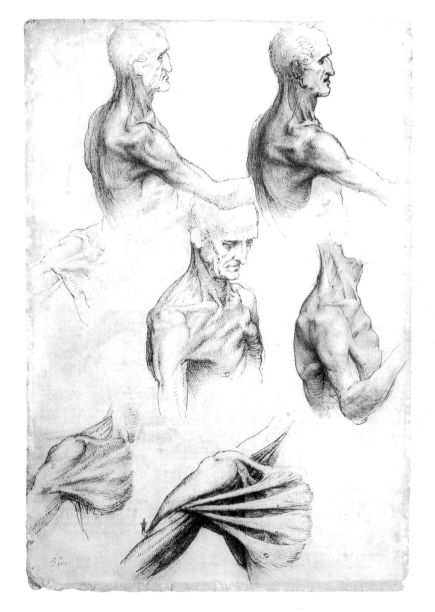

153

Charles Clement, who was disconcerted by Leonardo and could not forgive him for the uncertainty, resolved the situation with the assiduity of a court judge. In the collection of King Louis-Philippe there was a cedar panel on which was painted a mediocre figure. After the revolution of 1548, the king's collection was sold at auction and this panel was purchased by an art dealer with a particular idea in mind. He had the panel cleaned and discovered what he would never have dared dream:

Muscles of the Thorax and Shoulders of a Man

1510
Pen, brown ink, black chalk with wash, 29.8 x 19.8 cm
Royal Collection, Windsor Castle

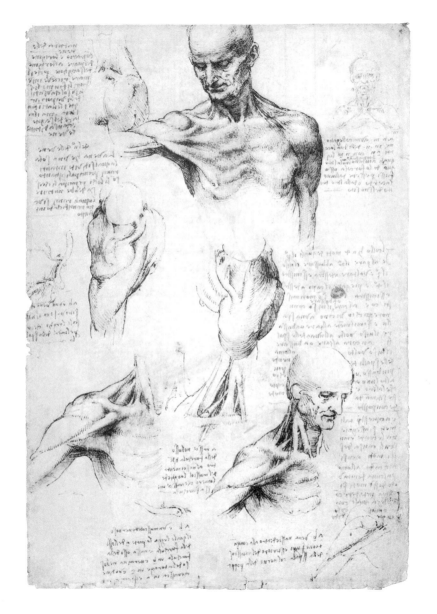

155

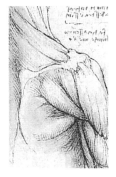

a painting by da Vinci, "a woman, lying down, almost naked, apparently done from nature." Clement saw it and declared that it was the *Mona Lisa*: "These are the same features, the same smile of mouth and eyes, the same marvellous hands." The authenticity of the panel remains in doubt, however. His students often hastened to copy the work of their master, some more successfully than others. The *Mona Lisa Undressed*, now at the Hermitage, with its uncertainly drawn shoulders, proves that

Muscles of the Arms, Shoulder, and Neck

after 1510
Pen and ink with wash, 28.5 x 19.5 cm
Royal Library, Windsor Castle

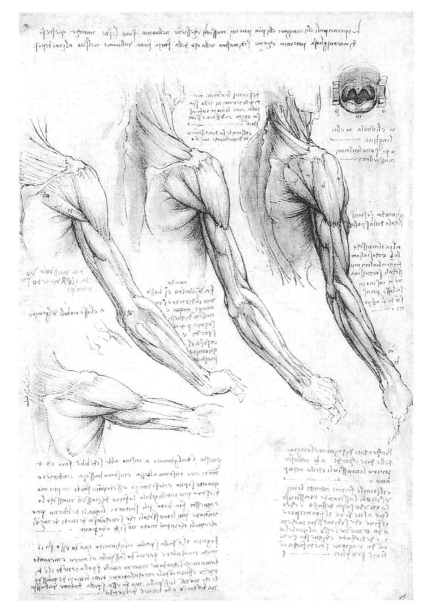

157

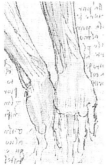

more than one artist tried to satisfy the curiosity of gawkers. There remained no more mystery, no sense of a dream. The commentator has simplified it all, but his beautiful capricious girl does not reveal the secret of the charming woman whose smile she took, accentuating its promises. This *Mona Lisa* is no more than a Neapolitan Carmen. Let us then leave this episode in Leonardo's life in the uncertainty it merits. Nevertheless, one can find a certain pleasure in believing that, before entering his darker days,

Muscles of the Arms, Shoulder, and Neck

after 1510
Pen and ink with wash, 28.5 x 19.5 cm
Royal Library, Windsor Castle

he refreshed his soul with the sweet clarity of a smile unlike any other. Giocondo consoled himself with the memory of two women. Did the third truly belong to the one who so longed for her and so envisioned her beauty that she seems to have been born of his artistic caprice? When he saw her, he could not fail to understand her. She went to him without haste, feeling the charm of this genius to, whom she was no stranger. There was between them something of a mysterious bond which united the object to the thought.

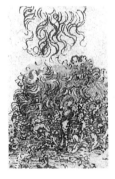

Cataclysmic Study

c.1511-1512
Charcoal or soft black chalk reworked with pen and golden and dark brown ink, 30 x 20.3 cm
Royal Library, Windsor Castle

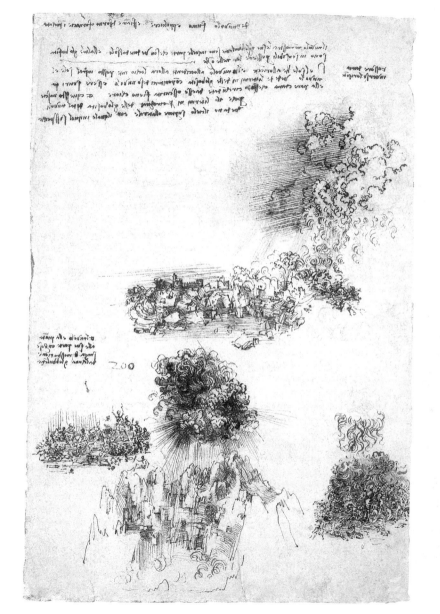

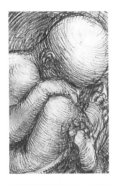

Their love was not the joyous folly of the springtime of life; it had subtleties, gentleness, and knowing caresses like the work born from it. Capricious, unknown to herself, this woman became infatuated with the man whose complex soul remained impenetrable to her, and whose lucid intelligence could decipher the secrets of her unconscious. Nobody was less a dupe of his love than Leonardo; he loved in her the infinity of her unselfconscious nature.

The Babe in the Womb

c.1511
Pen and ink with wash over red chalk, 30 x 22 cm
Royal Library, Windsor Castle

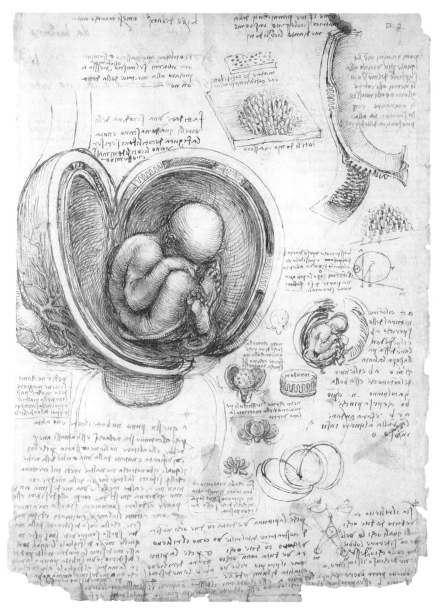

163

He studied her beauty; he rejoiced in her soul and her body and he left it to us to decipher the mystery of this analysis which had so impassioned him, "the more one knows, the more one loves."

No more in Florence than in Milan did painting occupy him completely. Among his best friends was a young gentleman, Francesco Rustici, who was devoted to the fine arts and especially enjoyed painting horses, of which he was a great admirer. He received an order to execute a group which,

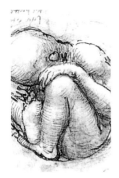

The Foetus in the Uterus

c.1511-1513
Pen and ink, 30.5 x 22 cm
Royal Library, Windsor Castle

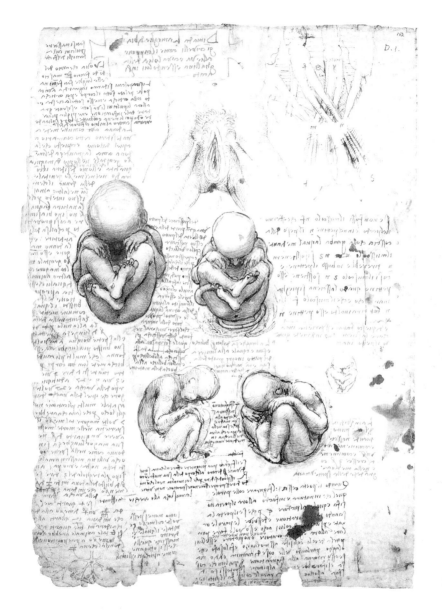

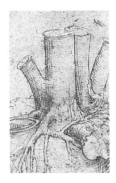

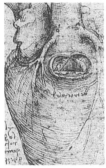

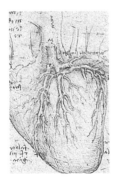

cast in bronze, stands today over the north portal of the Baptistery of Florence: St. John the Baptist, standing, preaches to two Pharisees who listen to him. Vasari tells that while Rustici worked on the model for this group he wanted nobody at his side but Leonardo, who did not leave him until the work was finished. At the same time, Leonardo again took up his projects for canalisation of the Arno. At the end of July 1503 he was at the Florentine camp under the walls of Pisa which, assaulted by the French, still defended its liberty.

The Heart

c.1512-1513
Pen and ink on blue paper, 41 x 28 cm
Royal Library, Windsor Castle

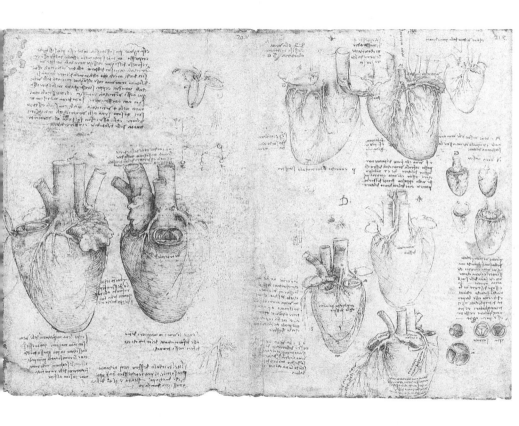

He called attention to the distance between the principal cities which the canal crosses, and the return value of the terracing work. The canal is not only a route that shortens distances; for him it was also a way to enrich and fertilise the land, to give motor power to the windmills, to have the water circulate through the fields by means of a clever system of irrigation. Leonardo thought in order to act. "To direct the Arno in its bed and on its surface; there is a treasure by the acre of earth for whoever wants it."

Self-portrait

c.1512
Drawing, 33.3 x 21.3 cm
Biblioteca Reale, Turin

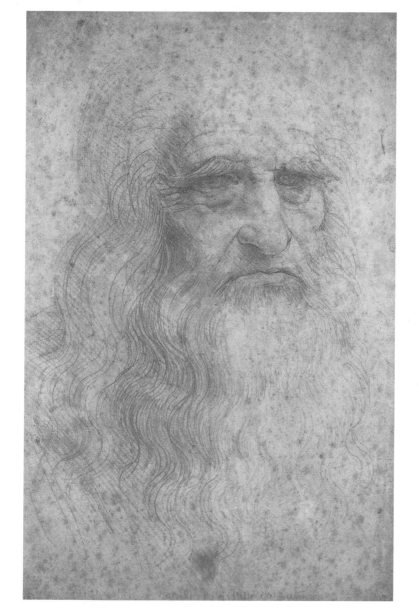

Leonardo did not want it for himself, but he wanted, at least, to give it to others. Beyond these works, he pursued the great labour of which the manuscripts confide. The seductive talker who liked to bring a smile to the lips of Mona Lisa in order to follow its undulating line, had singularly serious occupations himself. Brother Petrus Nuvalaria reproached him for no longer caring for anything but mathematics, for abandoning everything else for it, but the truth is that he cultivated every science with a

A Masquerader as an Exotic Pikeman

c.1517-1518
Pen, ink, and wash over black chalk
Royal Library, Windsor Castle

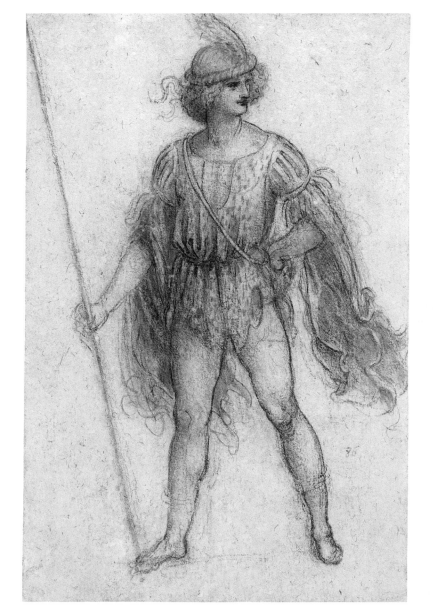

171

passionate curiosity that his genius allowed him to satisfy endlessly, nature never ceasing to beckon him to some new unknown. In the spring of 1506 Leonardo could no longer believe that the plaster with which he had covered the wall of the Council Hall would sooner or later be covered with the painting it held. The episode of the standard was finished, the cartoon ready.

Discouraged, he abandoned the work. His enemies were triumphant. Staying in Florence had become unbearable.

A Study for the Costume of a Masquerader

c.1517-1518
Black chalk, 14 x 17.3 cm
Royal Library, Windsor Castle

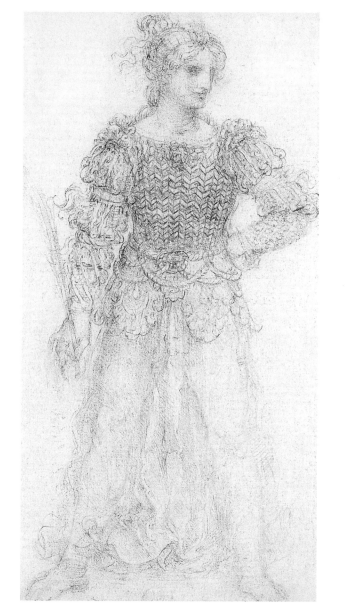

Florence shared Michelangelo's prejudices, abiet against him. His serenity, a little haughty, seemed like indifference in that turbulent city which was agitated with passions he did not share. During the summer of 1506 he obtained permission to return to Milan, where the French governor, Charles d'Ambroise, had called him. Maybe he was not unaware of the portrait of d'Ambroise, which was supposed to be by Andrea Solario (now in the Louvre); we know that he often worked on the paintings of his students.

Young Woman Pointing in a Landscape

after 1513
Black chalk, 21 x 13.5 cm
Royal Library, Windsor Castle

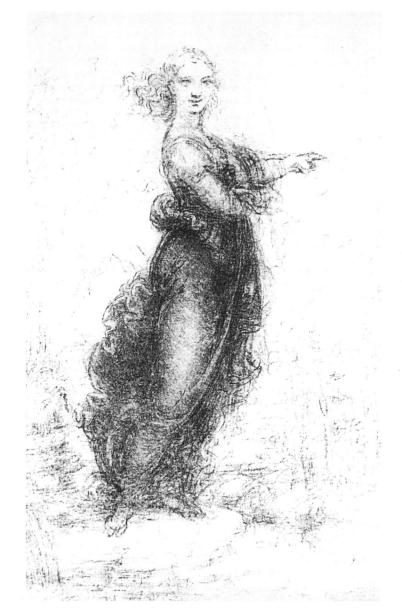

175

At that time one of his favourite places to stay was the villa in Vaprio, where a fresco of Madonna and Child attributed to him is still shown. It was the property of the family of Francesco Melzi, a young Milanese gentleman, who from then on would not part from the company of Leonardo. At the beginning of 1511 he was still in Florence, soliciting a judgment to settle a suit. Finally the case was brought to a close. He was to be freed of his worries and able to work in peace.

Saint John the Baptist - Bacchus

1510-1515
Oil on wood transfered on canvas, 177 x 115 cm
Musée du Louvre, Paris

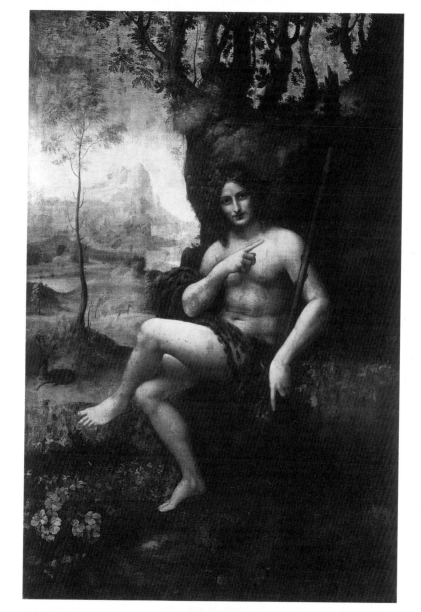

With so much still to do and getting close to old age, he prepared to return to Milan. Salai provided him with three letters: one for Charles d'Ambroise, the second for the head of the water regulation office and the third for Francesco Melzi. He apologised to the Governor for not having responded sufficiently to his benevolence. He wrote several times but received no response. Finally, an end of his trial came into sight; he would be in Milan for Easter.

St John the Baptist

1513-1515
Oil on wood, 69 x 57 cm .
Musée du Louvre, Paris

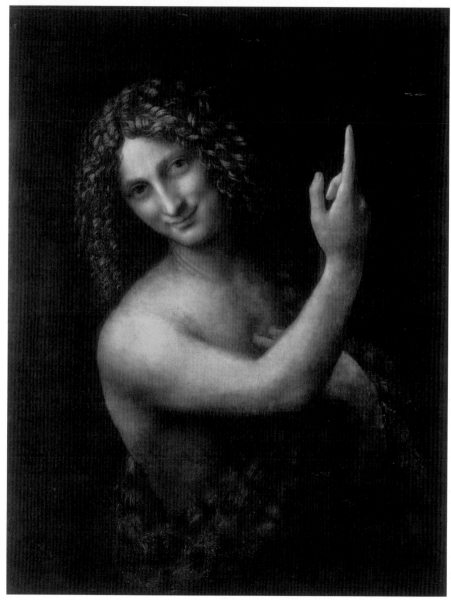

He returned with two Madonnas of different sizes which he had painted for the very Christian king. He asked His Excellency to grant him the ownership of the water concession; he hoped, upon his arrival, to make instruments and other things which would greatly please the king. The letter to the head of waterworks was almost in the same terms. What happened to the two Madonnas he alluded to here? We do not know. He reproached Franceso Melzi for his silence:

Studies and Positions of Cats

supposed dates: 1515-1520
Royal Library, Windsor Castle

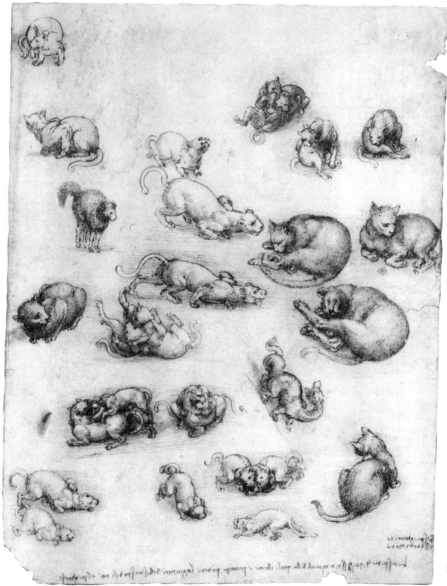

181

"Good morning, Signor Francesco. How in God's name is it possible that I have written you so many letters and that you have not answered? Just wait until I arrive! I will make you write so many, you will have them over your head!" Alas, while Leonardo's affairs were finally straightened out, those of the King of France were deteriorating. His fortunes, depending on those of the princes, had the same vicissitudes.

Studies for the Nativity

1480-1485
Pen and brown ink, 19.3 x 16.2 cm
The Metropolitan Museum of Art, New York

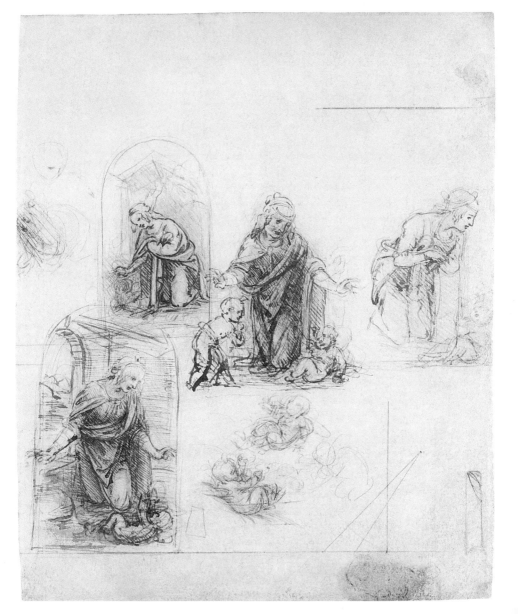

If the Maréchal de Clermont, Charles d'Amboise, did not answer him, it was because he had too many other problems. Satisfied to have humiliated Venice with the French army, and with a very Italian change-about, Pope Julius II had turned on his ally. Hating Alexander V, Cardinal of Rovere, he called on Charles VIII; his marching orders now were: "Out of Italy, Barbarians!" From October 1510 onwards Charles d'Ambroise was to fight against this bellicose Pope up to the walls of Bologna.

Mould of the Head and Neck of the Horse for the Sforza Monument

Undated
Ms. Madrid II, fol 157r.
Biblioteca Nacional, Madrid

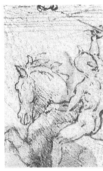

In November 1511 he died in front of Corregio. The same year, all the enemies of France – Ferdinand d'Aragon, Henry VIII of England, Emperor Maximillian, Venice, even the Swiss – formed the Holy League. Victories by Gaston de Foix re-established France's affairs briefly, but the young general foolishly let himself be killed under the walls of Ravenna (11 April 1512). Italy was lost. In December 1512, Maximilian Sforza, Ludovico's son, made his entry into Milan with 20,000 Swiss soldiers.

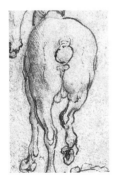

Study for the Fight with the Dragon

Undated
Inv. 781.r
Musée du Louvre, Paris

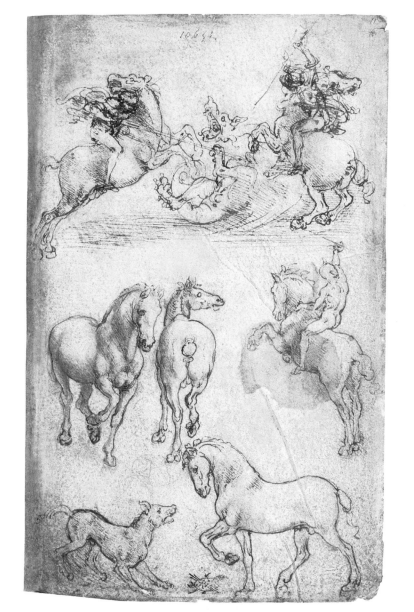

The French troops still occupied the citadel. A theatre of perpetual combat constantly crossed by foreign troops, the dukedom was in disarray. An artist no longer had anything to do in Milan. "On 24 September 1513," wrote Leonardo, "I left Milan for Rome with Giovanni, Francesco Melzi, Salai, Lorenzo and Fanfoia." It was a veritable emigration. The students followed their masters. At over sixty years old, Leonardo had to take to the road once again, to chance fortune that does not like the elderly.

Study for the Fight with the Dragon

Undated
Inv. 781.r
Musée du Louvre, Paris

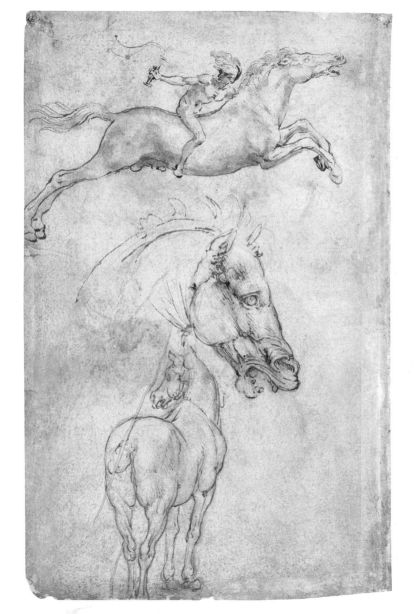

189

Perpetually starting over is hard labour. Ageing happens, one feels the effects but one must keep the ardour of youth; in the impoverishment of life whose source has dried up, what appears to be fecundity is nothing but superabundance. When one is Leonardo, one follows the effects to find their causes and consoles oneself for the pain by using one's intelligence. Alas, one may not have experienced it, but nonetheless know that it exists.

Heads in Profile

c.1478
40.2 x 29.0 cm
Royal Library, Windsor Castle

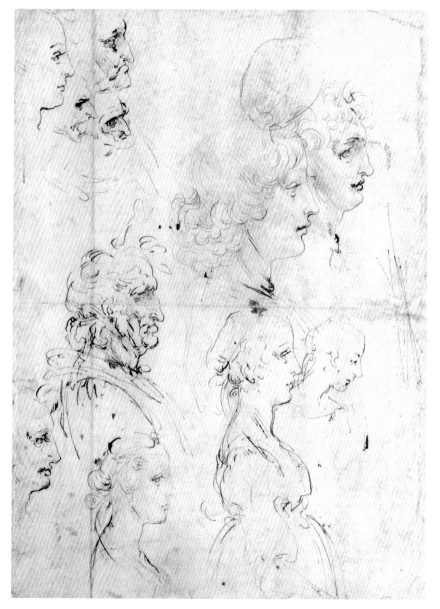

191

The spirit is like the sky, full of stars, which first shine without one's thinking about it, but then go out, one by one, leaving only the serenity of a deep blue night which has lost its brightness. In 1513 Leonardo accompanied a friend to Rome in the hope of being introduced to the Pope, but the great artist found only disappointment in Rome. Everyone united against the newcomer. His friendship with the King of France, the enemy of the day, was used against him.

Five Grotesque Heads

Undated
Pen and ink
Royal Library, Windsor Castle

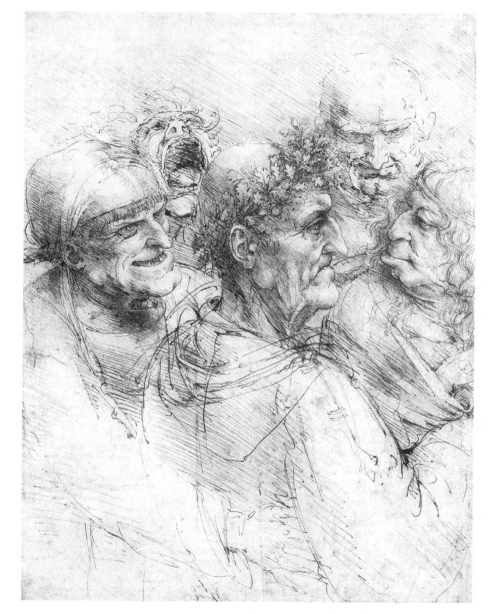

The Pope, who was curious about astrology and alchemy, took an interest in Leonardo's scientific experiments, and even more perhaps in his bizarre inventions, the play of his subtle genius in which more than one fruitful idea was hidden. Leonardo had again taken up his work on the flying machine. Vasari tells us that he made animals in different shapes from a thin film of reduced wax, that he filled them with air and made them fly; it was the idea for the hot air balloon.

Head of a Woman

Galleria degli Ufizzi, Florence

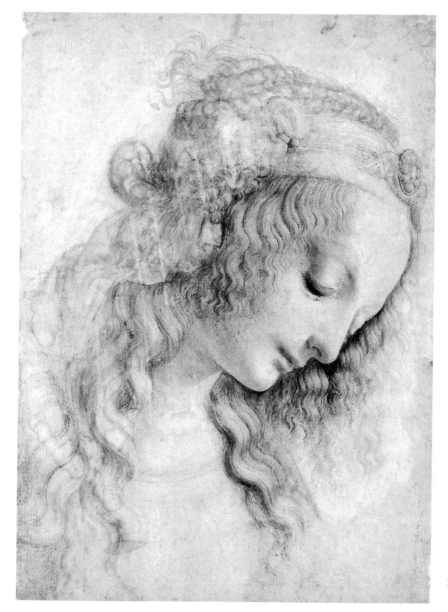

He was also very busy with mirrors and optical instruments. He still had a taste for ingenious and singular jokes. He had attached to a living lizard hollow wings made from the scales of other lizards, which he filled with quicksilver. When the animal walked, the wings would beat. He then added eyes, horns, and a beard. In short, he created a sort of monster that one could only look on with horror.

A Portrait of a Young Woman in Right Profile

c.1485-90
Metalpoint, 31.8 x 19.9 cm
Royal Library, Windsor Castle

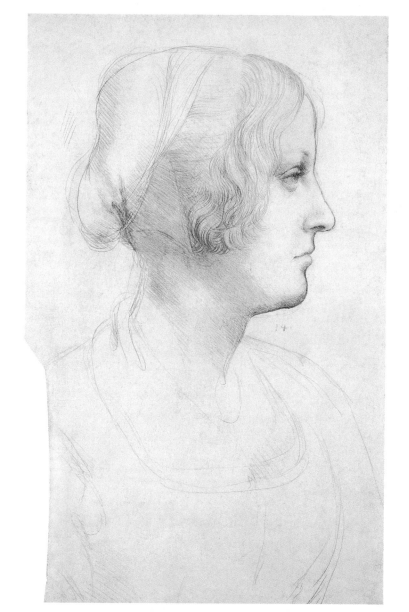

When the Pope decided to order a painting from him, Leonardo started distilling herbs to make varnish. An enemy hurried to tell Leo X about it and he said,

"Alas, this man, be assured, will not do anything, since he is thinking about the end before he even begins."

His friends did not hesitate to report this remark to the painter. For the first time he encountered disdain. The charm, which until then had seemed to accompany him, was no longer working.

The Head of a Youth in Right Profile

c.1510
Red chalk, 21.7 x 15.3 cm
Royal Library, Windsor Castle

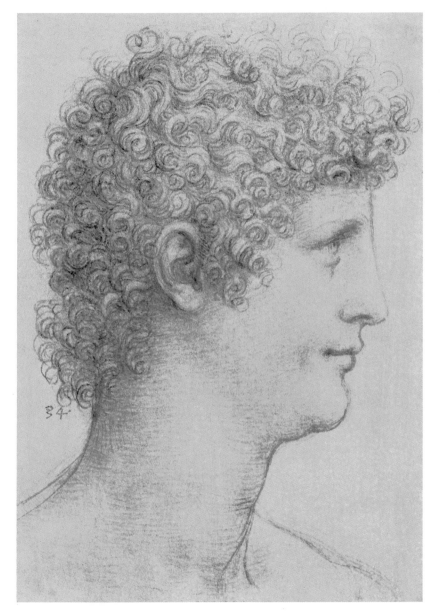

34·

199

A new generation was being born, one which he had taught but of which he was not a part. But how many things did he know that they still did not? How many verities he had he seen that would never appear to them? In that, he was younger than Michelangelo and Raphael! Small annoyances, which are hard for great spirits, came at him from all sides. The draft copy of a letter that he wrote to Julio de Medici has recorded some of these memories for us.

Profiles of a Young and an Old Man

Red chalk, 21 x 15 cm
Galleria degli Ufizzi, Florence

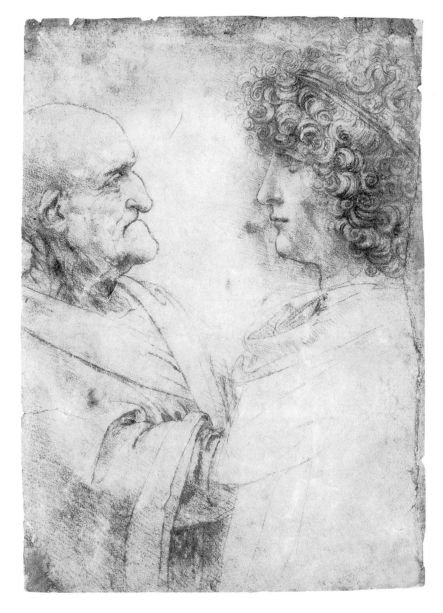

We find that he was ill at the same time as his protector. For instance, Leonardo continued his studies of anatomy in Rome; Master Jean seized the occasion to denounce this fact to the Pope by presenting Leonardo's curiosity, which did not recoil from sacrilege, in the blackest of colours. He worried the conscience of the director of the hospital where Leonardo had much accessed that the painter was banned from dissections and refused cadavers.

Study of a Hand

c.1483
Black chalk with white highlights, 15.3 x 22 cm
Royal Library, Windsor Castle

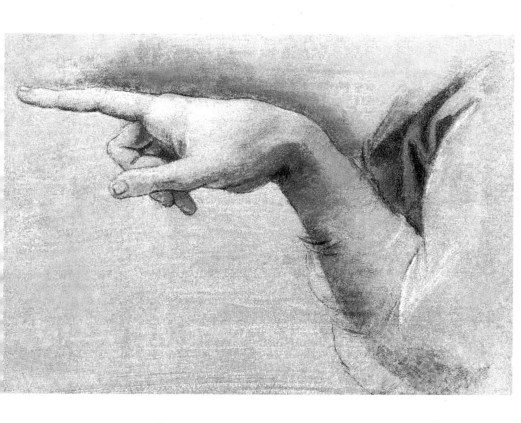

Called to Italy by Venice and Genoa, the young King of France, with incredible audacity, crossed the Alps at the Argentière pass. On August 15th he entered Italy. Hardly had Leonardo been informed of the arrival of the French than he left Rome and rejoined Francois I at Pavie. He was put in charge of organising the entertainments held in that city and he built a mechanical lion which, on arriving in front of the king, opened and covered the royal feet in France's national flower, the fleurdelys.

Study of a Nude

Undated
Royal Library, Windsor Castle

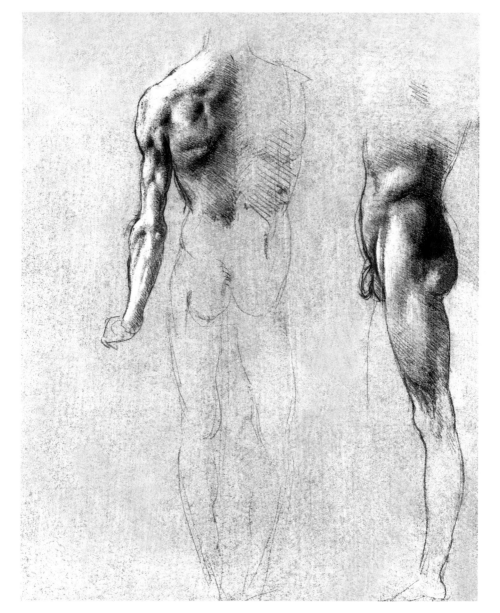

On September 13th, Marignan's victory gave the king the dukedom of Milan. Leonardo accompanied the victor to Bologna where Leo X came to request a peace settlement. The friendship of Francois I, who treated him with filial respect and called him "my father", had made him fashionable again. He tasted the headiness of this French success. In Bologna he had his revenge for the humiliations he had suffered in Rome. The Pope and the cardinals, coming there as the vanquished, witnessed the triumph of the man they had disdained.

Studies of Anatomy

Biblioteca Ambrosiana, Milan

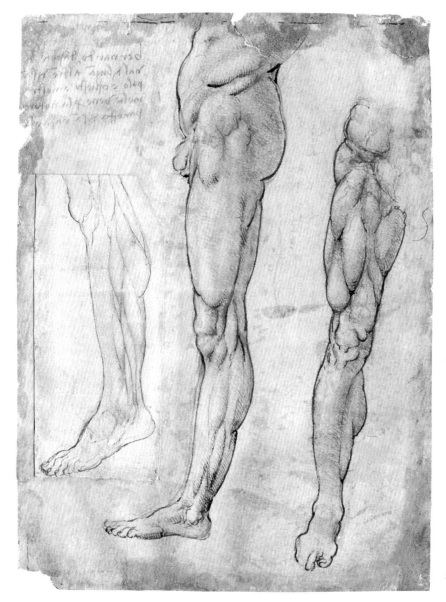

He was at all the parties, mingling with the aristocrats, amusing them at the expense of his enemies, displaying that grace, wit and those talents they had not known how to use in Rome. In December 1515 he returned for the last time to Milan, his second home, the city he seemed to have preferred and where he left the memories of his most fruitful and happiest years. In 1516 he was in France, where he had followed the king. Leonardo had always rejected the narrow mindset of regional patriotism,

The Head of St James and Architectural Sketches

c.1495
Red chalk, pen and ink
Royal Library, Windsor Castle

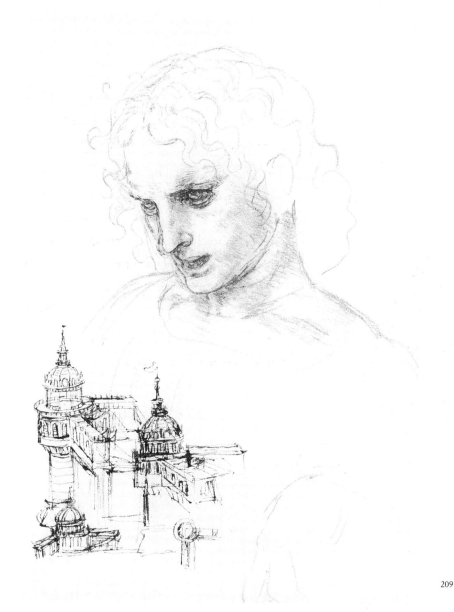

but surrounded in France by the confusing murmur of an unknown language, a new climate and foggy days when the sun paled, he discovered what a homeland was, and that Italy was his. Brusquely separated from the land of his youth and his memories, he felt his age more keenly. One imagines that he felt some joy on a visit that took him to Italy. He saw the cardinal, showed him his paintings, and opened for him the boxes holding his precious manuscripts. He hoped that these notes, volumes of them, grouped as treatises,

Three Dancing Nymphs

Undated
Galleria dell'Accademia, Venice

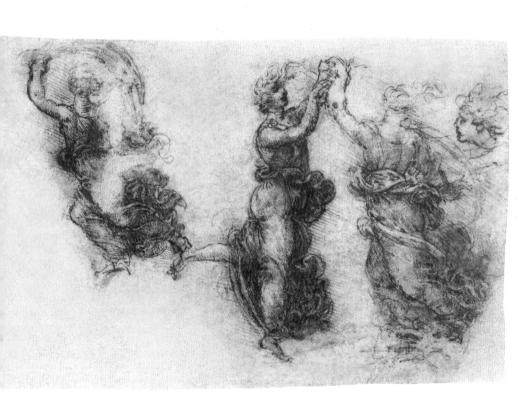

would justify and protect him from the accusation of having badly employed the genius he would have to account for to God.

Although barely sixty-four, he appeared to be over seventy. Paralysis had already contorted his hand and barred him from doing any new work. He had worked too much, thought too much, and suffered too much. One does not carry with impunity within oneself and one's many-faceted talents, several beings, all wanting to draw on the same source at the same time, and not risk its depletion.

Hercules with the Lion Nemean

c.1505-1508
Charcoal and metalpoint, 28 x 19 cm
Biblioteca Reale, Turin

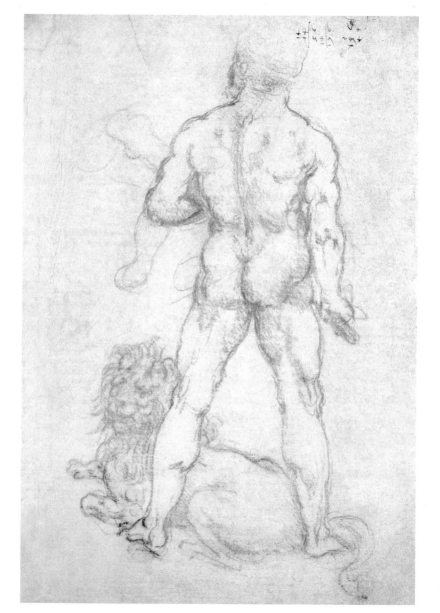

213

That great work, always dreamed of, would not be achieved. He knew it, he felt it. His strength was leaving him. He would need another life, or more than one life, and the thought that should console him was that the route he had opened would reach to infinity.

He became still weaker and remained ill for several months. Death claimed his robust body slowly. Finally, on 23 April 1519, he brought in M. Boureau, court notary of Amboise, in order to dictate to him his last wishes.

Drapery for a Seated Figure

Undated
Brush and gray tempera, highlighted with white, on gray prepared linen, 26.6 x 23.3 cm
Musée du Louvre, Paris

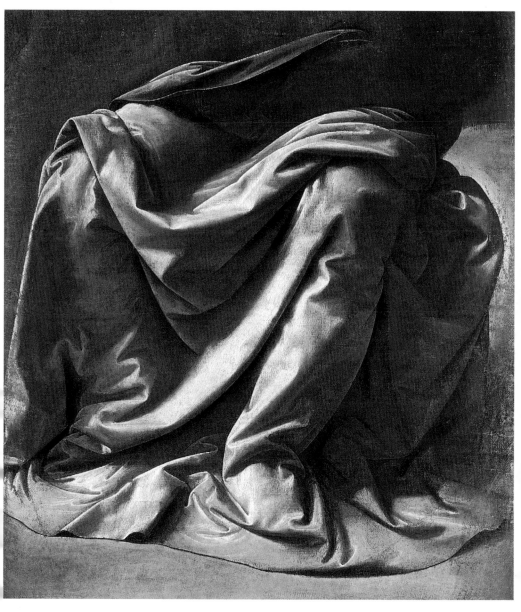

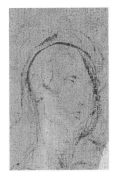

First he recommended his soul to Almighty God, the glorious Virgin Mary, St Michael and all the blessed angels and saints in Paradise.

"Item: said testator wishes to be buried in the St Florentine Church of Amboise and that the body be carried by the church chaplains. Before his body is taken to said church, the testator wishes that three high masses be celebrated in that church, with deacons and subdeacons, and that, on the day when the three high masses are celebrated, thirty more low masses be said at St Gregory;

Drapery for a Seated Figure from the Front

Undated
Brush and gray and brown tempera,
highlighted with white, 26.8 x 17.8 cm
Musée du Louvre, Paris

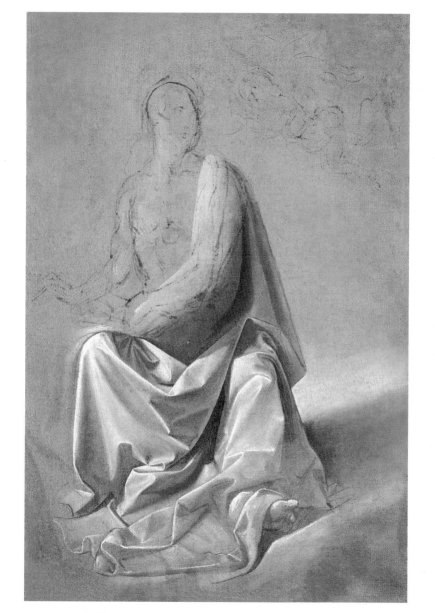

item: and that the same above service be held in St Denis; item and in the church of the monks similar religious services be held."

The spiritual aspects taken care of, he left to Francesco Melzi, a gentlemen from Milan, in recompense for his past good services, all his books, instruments, and drawings related to his art and work as a painter; to Battista of Villanis, his servant, half of the garden he had outside the walls of Milan, and the other half of that garden to Salai, who had already built a house on it; he left to Mathurine,

Study of Weapons

Undated
Metalpoint, pen and brown ink, 21 x 39 cm
Musée du Louvre, Paris

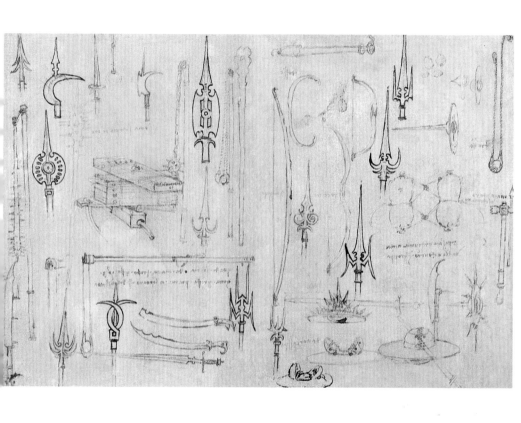

his maidservant, a piece of good fur-lined clothing of black cloth and two ducats, to be paid at once. A codicil left to Battista de Villanis the water concession given to him by Louis XII, a happy memory, and also the furniture in the Cloux house. The will is clear-cut and worthy of his lucid mind and heart. He remembered the poor; he had good words and remembrances for his servants and his friends; he shared with them, with the exception of the brothers who had disowned him, all that he had.

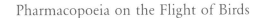

Pharmacopoeia on the Flight of Birds

1505-1506
Pen and ink, 21.3 x 15.3
Biblioteca Reale, Turin

221

He never knew how to hate and died on 2 May 1519 without rancour, thanking those who loved him, and forgiving the rest. To judge Leonardo, one must remember that he inspired great affection. We know the legend that has the great artist dying in the arms of the King of France. Because he saw in Leonardo one of the rarest minds nature had created, and because he showed him the respect of a son, allowing him a peaceful death with the illusion of still being useful,

The Distance from the Sun to Earth and the Size of the Moon

1506-1508
Pen and ink, 29.3 x 22.1 cm
Private Collection , Seattle

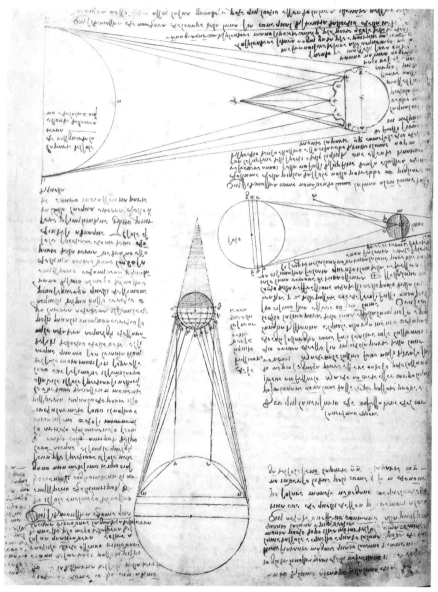

Francois I deserved the legend that grew around him and which reached the studios of Florence where it was recorded by Vasari. The truth is that on the day of Leonardo's death, the king with all his court was at St-Germain de Laye. In his letter to Leonardo's brothers, Melzi says nothing of a visit from the king, and Lomazzo writes in some rather flat verses: "Francois, King of France, wept when Melzi informed him of the death of da Vinci who, while he lived in Milan, painted *The Last Supper* (p. 83) which, surpasses all other works of art."

Study of Geometric Transformations

Undated
Codex Atlanticus, fol. 167r a-b, 28.9 x 13.4 cm
Biblioteca Ambrosiana, Milan

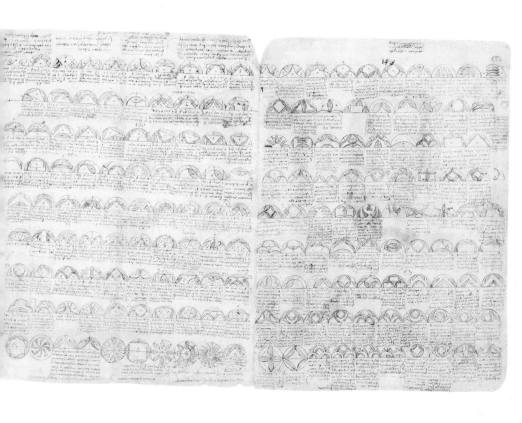

So that great life came to a close as is the way of all life; the phenomenon of the genius's thought was no longer. Day by day, the most beautiful souls are extinguished; ephemeral masterpieces, nuance by nuance, they fade into the shadows of night.

Vasari has him renouncing his thoughts in the last months of his life, accusing himself on his deathbed of having misused his genius. When the king entered, he sat on his bed and while talking about his illness and suffering,

A Sheet of Pictograms, Drawn over an Architectural Plan

c.1490
Pen and ink, 30 x 25.3 cm
Royal Library, Windsor Castle

"he says how much he has offended God and men in this world, by not having worked at his art, as he should have."

This is a judgment in which the foolishness of the follower is added to that of the painter. It is difficult to know what to think about Leonardo's return to religion. Possibly his recommendations to all the saints are just banal formulas. Three high masses, ninety-nine low masses, so many priests and monks, are maybe only surprising to our age.

Vertical Flying Machine

1487-1490
Pen and ink, 23.2 x 16.5 cm
Institut de France, Paris

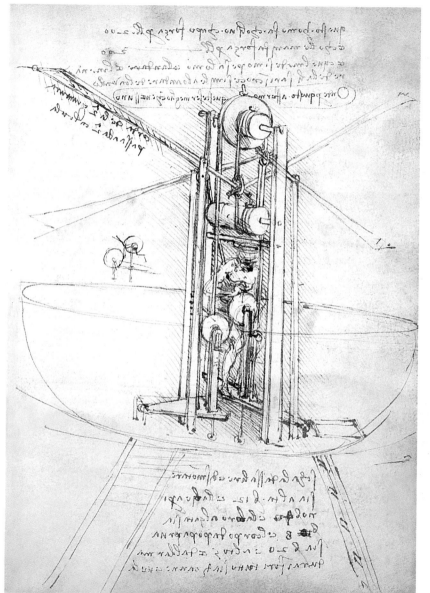

229

At the burial of his servant Catarina, he wanted four priests and four the clerics. He wished to be buried with all the formalities, decently, as appropriate for the protégé of the very Christian king. But then, what is important about a man is his life, not his death, even when the former is not, by voluntary sacrifice, a living work. That he cast a melancholy backward glance at his past, that he had once trusted Melzi with his unfinished drawings, that there are so many lost truths in his indecipherable manuscripts;

Different Types of Chains

1493-1497
Pen and ink, 21.3 x 15 cm
Biblioteca Nacional, Madrid

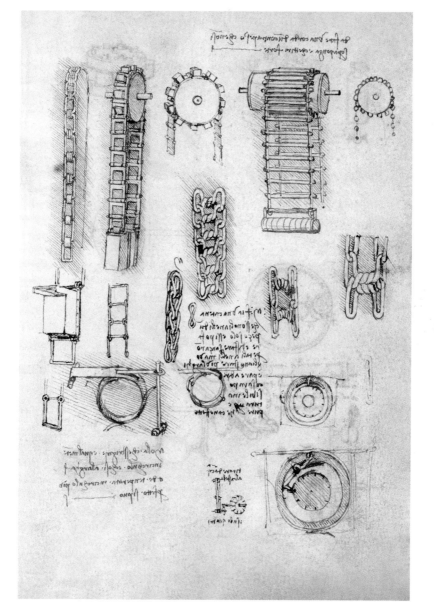

that at the final moment he felt pain at leaving life without recognition, without having pronounced the supreme word he believed he had only stuttered, even in his masterpieces - that was his destiny. Regret for the good he could have done may have obscured the good which he *had* done. But why remorse? Did not he said: "A life well lived is long enough."? Who else had worked more, and what work had been more fruitful? Who else could boast of owing to himself alone a fuller harvest of ideas?

Chariot Armed with Scythe

c.1485
Pen and ink, metalpoint, 21 x 29.2 cm
Biblioteca Reale, Turin

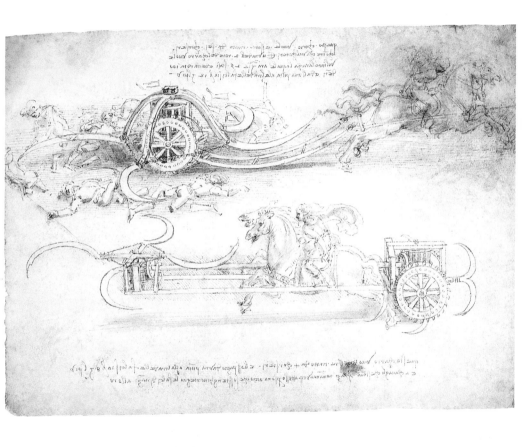

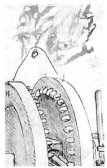

If some bitter thoughts were mixed with the feeling of having merited the long rest of death, it was because he was not thinking of himself; he was thinking of others, the society of minds, the eternal work that men build for themselves little by little, the truths they discover, the beauty they create. Was he guilty of allowing his multiple genius to carry him in all directions? Was it his duty to resist? As a scholar, why should he sacrifice science? As a thinker, thought?

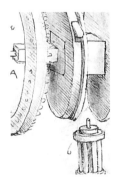

Mechanism for Alternative to
Continuous Movement

c.1485
Pen and ink, 27.8 x 38.5 cm
Biblioteca Ambrosiana, Milan

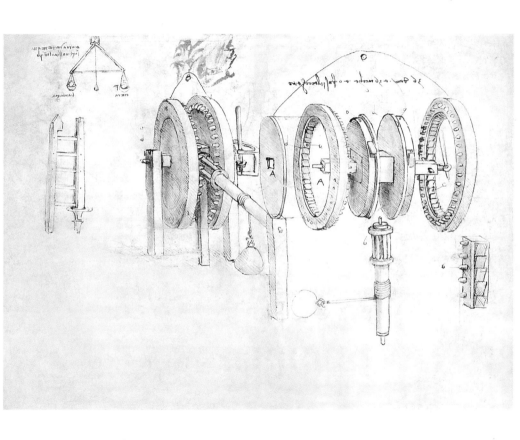

235

He had accomplished the task of being a man, indeed he was the quintessential man, who has left in the harmony of his mind and body, in the equilibrium of all his faculties, an example for humanity to which we still turn with pious admiration.

And, nevertheless, at the end of that life – and what a life! – why that sense of melancholy? Why not the feeling of achievement, of time so well spent that it would be ungrateful to regret that it had happened?

Giant Mechanical Digger

c.1503
Pen, ink, and wash, 28 x 40 cm
Biblioteca Ambrosiana, Milan

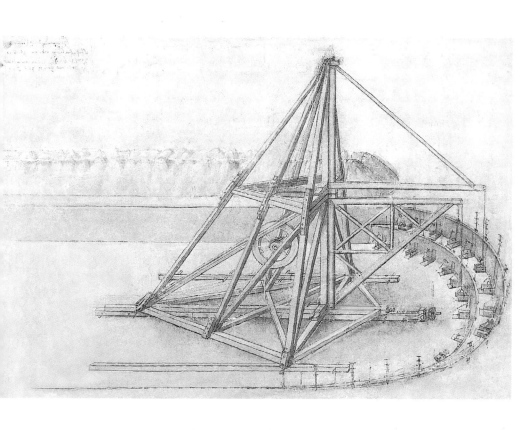

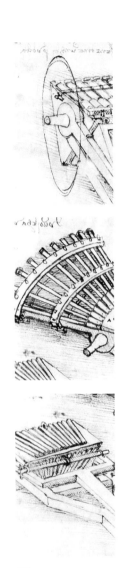

Raphael died at the height of his genius and fame, and that life cut off in full bloom does not seem more charmed and more desirable. Michelangelo, always irritable, found in that inner tempest whatever happiness there was in his Dantesque soul. Why does the life of da Vinci, like his exquisite works, leave us vaguely uneasy? In *The Marriage of the Virgin,* which he painted for the church in Sarrono, Bernardino Luini wanted the master to be present in the work which he would not have been able to paint without him.

Machine Gun

c.1482
Pen, ink, and black chalk, 26.5 x 18.5 cm
Biblioteca Ambrosiana, Milan

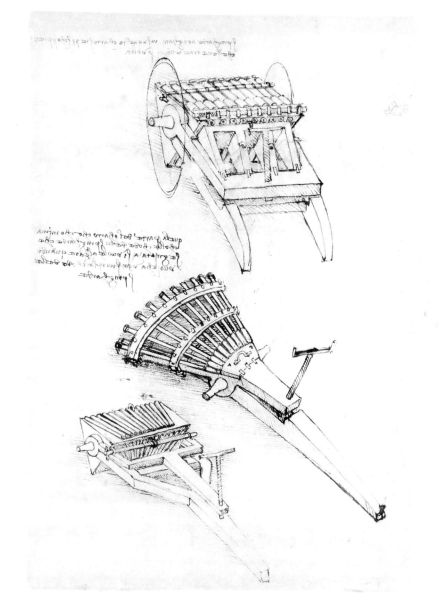

239

He painted Leonardo's head in the background with his long hair mingling with the brilliant white of that beard that reached his chest. That is the memory that Luini kept of his venerated master. More expressive still is the Turin drawing where Leonardo himself left us his own image. Indicated by a few pencil lines is his undulating hair and beard, framing the unforgettable mask that emerges from them with a kind of violence.

Rapid Fire Trigger

Undated
Codex Atlanticus, fol. 387r
Biblioteca Ambrosiana, Milan

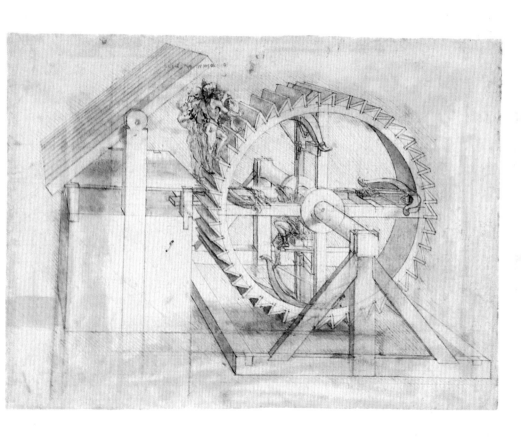

The forehead is bare and crossed with wrinkles; thick eyebrows cover the upper eyelids, burning eyes stare imperiously with the folds at the top of the nose showing intense concentration; the lower lip advances in a disdainful pout and the two corners of his mouth are turned down in a painful fold. It is the head of an old eagle accustomed to great flights and having too often seen the sun face to face. Da Vinci's melancholy is that of great hopes and vast thoughts.

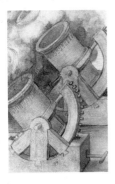

Mortars Firing Cannonballs

Undated
Codex Atlanticus, fol. 9v-a.
Biblioteca Ambrosiana, Milan

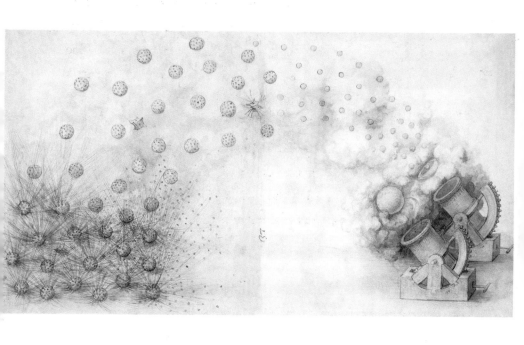

Michelangelo and Raphael are men of their time. There is a perfect balance between their genius and their environment. They are saluted, acclaimed, recognised. But their work is limited by, and proportionate to, their strengths; they had the joys of a labourer who sees his job is well done. Leonardo is the precursor of an age to come. He dreamed of giving to man, through science put to the service of art, the rules of the universe.

The Etruscan Mausoleum

Pen and ink, brown wash, and black chalk, 19.5 x 26.8 cm
Musée du Louvre, Paris

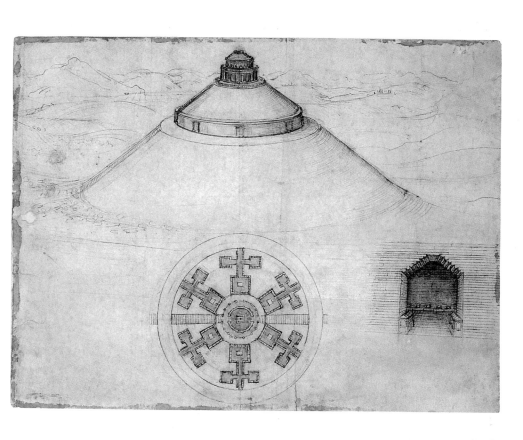

The distance that separated him from his dream, in the measure that he advanced, receded; we still have not reached it. That man, who lived so much with men, that favourite of princes, of the aristocratic ladies of Milan and Florence, that master loved passionately by his disciples, had taken on the face of a recluse.

Is it not that he carries within himself the vision of a new world, as a Moses of a promised land seen from afar, which he cannot reach?

Automobile

Undated
Codex Atlanticus, fol. 296v-a.
Biblioteca Ambrosiana, Milan

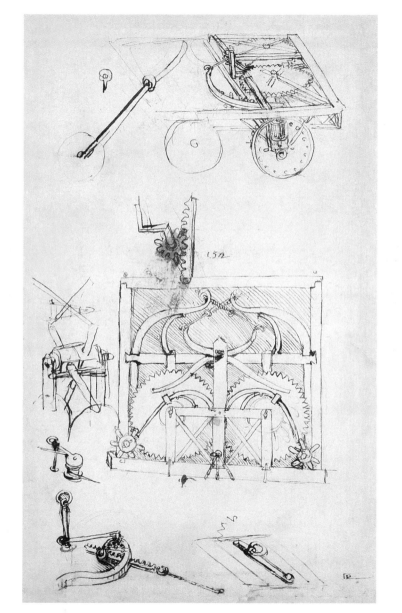

List of Illustrations